Photographing Nature

INSECTS

Heather Angel MSc FIIP FRPS

First Published 1975

© Heather Angel 1975

FOUNTAIN PRESS, ARGUS BOOKS LIMITED
Station Road, Kings Langley, Hertfordshire, England

CONTENTS

INTRODUCTION

Insects are the most abundant animals in the world. In any terrestrial habitat they provide endless subjects for photography – some beautiful, some bizarre. Even though they are so numerous, most of them are small and they are often very active. Their dynamic nature means that achieving good insect pictures is a challenge which taxes both patience and skill. Although spiders are not insects, several photographs of them have been included, since they are likely to be found when looking for insects.

This book aims to stimulate both entomologists and photographers to experiment with new techniques for photographing insects. A practical approach has been adopted throughout and as many techniques as possible have been illustrated with photographs.

So that the maximum amount of space could be devoted to the problems and techniques of insect photography, it is assumed that readers will have a basic grounding in photography. All the photographic terms mentioned in this book are defined in Appendix A, and a summary of the equipment and accessories relating to insect photography – both in the field and indoors – is given in Appendix B. All the monochrome and most of the colour photographs were taken on a Hasselblad camera. All others were taken on a Nikkormat camera.

The fine structure of the anatomy of insects is missed by the casual observer. With close-up and macrophotography, a close study of small insects and even parts of larger insects, opens up a new and exciting world.

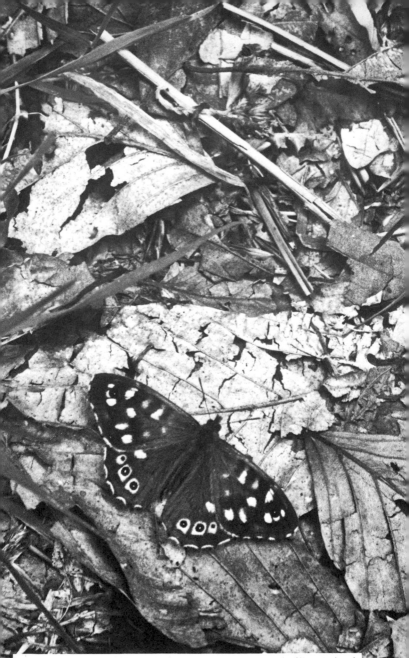

Fig. 1.1 Speckled wood butterfly *(Pararge aegeria)* resting on leaf litter in beech wood. Available light on overcast day.

CHAPTER 1 INSECTS AT LARGE

Insects are remarkably diverse in their form and colour. They are the most abundant group in the animal kingdom – with about one million known species ranging from beetles and moths to ants and midges. All winged invertebrates are insects, but not all adult insects have wings. Insects are easiest to recognize during their adult stage, since the body is divided into three parts, the head, thorax and abdomen, with three pairs of legs and one or two pairs of wings on the thorax. In dense concentrations, insects can cause havoc by destroying crops or carrying disease, although relatively few are regarded as being pests by man. Some insects are of great economic value to man: bees not only provide honey, but also pollinate flowers. Many others, because of their small size or drab coloration, pass unnoticed by all except the 'bug' hunter. So the brightly coloured butterflies, moths and dragonflies are most often selected as photographic subjects, simply because they are so colourful or beautiful. This book is by no means concerned solely with beautiful insects: but rather it aims to relate photography to all types.

The majority of insects are small animals which need to be photographed at close range. Therefore part of this chapter outlines the basic essentials of close-up photography, so that they can then be applied to the various techniques for specific subjects described later in the book.

Insects can either be stalked and photographed *in situ,* or else captured or bred for studio photography. Both approaches are valid, providing studio portraits are not claimed as having been taken 'wild and free'. Critical close-ups of certain species – notably very active or small insects and aquatic forms – can be achieved only under controlled conditions indoors.

Insect locations

Insects live in every major terrestrial habitat, and many micro-habitats – including dung, rotting corpses, and streams fed by hot springs. Even the smallest of gardens will contain many insects. They are also abundant – especially during their larval stages – in freshwaters. Relatively few insects have penetrated the marine environment. The few which have, include primitive springtails and bristletails, as well as kelp flies and an oceanic strider. The

Fig. 1.2 Female glow-worm (*Lampyris noctiluca*) glowing at night. Studio, time exposure, with extension tubes. ×5

distributions of many insect species are restricted to a single habitat and frequently to a single food plant or animal. So, by getting to know the food of any particular species, the field of search becomes narrowed down.

Unless one particular kind of insect is required for photography, however, very often the best approach is to walk through an area and to see which insects are most abundant or most approachable. Woodland rides–especially when a variety of herbaceous plants are flowering–are rich sites for butterflies, flies and day flying moths.

Ponds, streams and boggy areas are obviously most suitable places in which to search for dragonflies, and also alder flies, caddis flies and stoneflies. In drier grassy areas, grasshoppers and crickets occur, often advertising their presence by stridulating. At dusk in mid–summer, female wingless glow-worms (related to tropical fire flies) can be spotted in grassy limestone areas, by the light produced from the light organs on the underside of the last three abdominal segments (Fig. 1.2). The winged male beetles are attracted to the light.

Some flowers–like buddleia and catmint–are particularly attractive to butterflies and bees and so are well worth watching to see what species visit them. Bramble flowers will attract a wide variety of insects over a period of several weeks. Recording all the species which visit a particular kind of flower, is a useful photographic exercise.

Old rotting stumps and fallen trees are sought after as breeding sites by several beetles and leaf cutting bees. In order to see and photograph these insects, at least part of the trunk has to be destroyed. This destruction of a limited micro-habitat clearly reduces potential insect breeding sites as well as substrates for certain fungi, mosses and lichens; the necessity for conservation should always over-rule the urge to photograph.

Getting in close

Close-up photography is usually regarded as beginning at the shortest camera-to-subject distance at which a standard lens (not a macro lens) can be focused without any accessory, through to a life size image (1:1). The term *macrophotography* applies when magnifications of greater than life size are recorded on film. Whereas the term *photomicrography* should be used only for photographs taken with the aid of a microscope. The upper end

of the macrophotography scale and the lower end of the photo-micrography scale can, in fact, overlap. In this book examples can be seen of both close-ups and macrophotographs. Because it is possible to enlarge original life-size close-up negatives or transparencies to several times greater than life-size, original macro-photographs are denoted by the letter M after the magnification.

Accurate focusing is critical for close-up and macrophoto-graphy and so a SLR camera is preferable for this kind of work and virtually essential for photographing active insects. Although I do know of a few extremely patient individuals who manage to work with TLR or even non-reflex cameras.

The cheapest way to get in close, is to attach a close-up or supplementary lens in front of the camera lens, thereby shortening the focal length of the lens. Close-up lenses are light in weight and convenient to use, but they are not generally manufactured to the same optical quality as the camera lens itself. Therefore definition may be lost, especially when large apertures are used. Also, the extent by which close-up lenses magnify the image is limited, generally available as 1, 2 or 3 dioptres with a +2 dioptre lens magnifying twice as much as a +1 dioptre. One major advantage is that there is no significant loss in light intensity reaching the film, which is often an important factor when photographing an active insect under low levels of available light. In fact, high quality close-up lenses can be extremely useful for *in situ* action pictures. Also, close-up lenses are the only way to get in close with a fixed lens.

For cameras with interchangeable lenses, either extension tubes or a bellows extension can be inserted between the lens and the camera body for magnifications of up to life size (by using an extension equal to the focal length of the lens, i.e. 50 mm with a standard 50 mm lens) or beyond 1 : 1 (with bellows). As tubes and bellows both extend the lens-to-film distance, an increase in exposure is necessary to compensate for the additional distance the light has to travel from the lens to the film. Cameras which have a built-in TTL metering system, allow for quick and easy determination of the correct exposure increase. Alternatively, if close-up tables are not supplied with the tubes or bellows, the exposure increase is calculated by using the amount of extension (in mm) and the focal length of the lens:

$$\frac{\text{f/number}}{\text{to be used}} = \frac{\text{aperture taken from}}{\text{light meter reading}} \times \frac{\text{focal length of lens}}{\text{focal length of lens} + \text{extension}}$$

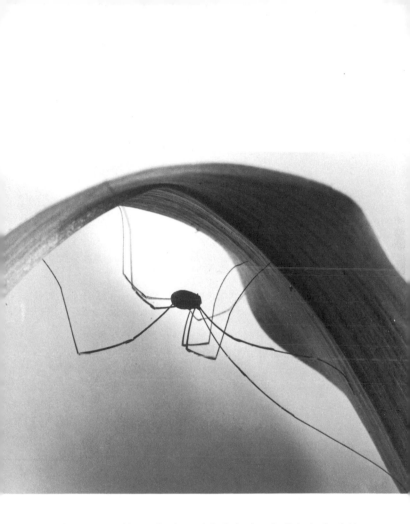

Fig. 1.3 Harvestman spider resting beneath leaf. Against the light in the field.

For example, if 25 mm extension is used with a 50 mm lens, and the light meter gives a reading of 1/60 second at f/8, the iris diaphragm needs to be opened up by one stop:

$$(f = 8 \times \frac{50}{50 + 25} = 5.3 - \text{approximately } 5.6)$$

Alternatively, a slower shutter speed of 1/30 second, coupled with the original aperture of f/8 is equivalent to opening up by one stop.

Remember that the extent of the increase in exposure will vary depending not only on the amount of extension used, but also on the focal length of the lens. Therefore when using a longer focal length lens – such as 135 mm – for a given extension, the exposure increase needed will be less than for a 50 mm lens.

Extension tubes are usually cheaper than bellows. Also, because tubes are rigid and of fixed lengths, precise reproduction scales can be noted. The two main advantages of bellows are that they provide a continuous focusing range and greater possible magnifications than a single set of tubes. However, if they are used in the field for magnifications greater than life size, the depth of field will be very limited, unless a fast film or flashlight is used. Most extension tubes, but not all bellows, are fully automatic. When non-automatic tubes and bellows are used, the lens has to be stopped down – either manually or by using a Z ring and a double cable release.

A particularly useful lens for close-up photography, is a macro lens, which has its own built-in extension. Usually having a focal length equal to a standard lens (50 mm), a macro lens can be focused from infinity down to half life size, without any extra extension.

Depth of field This is the extent of the acceptable focus in front of and behind the plane on which the lens is focused. Depth of field depends on the focal length of the lens, the aperture and the magnification. It can be increased either by stopping down to a smaller aperture or by decreasing the image size. With all close-up work, and most especially macrophotography, the depth of field is limited and therefore critical focusing is essential. Even a slight adjustment to the lens focus will make a considerable change to the magnification at close range. So that if a precise magnification is required, the focusing must be done by moving the camera backwards and forwards until the subject comes into focus. This can be done manually or by attaching the camera to a focusing slide on top of a tripod.

Focusing is most easily done when the lens is fully opened; but it is worth remembering that when the lens is stopped down, the depth of field increases more behind the point of focus than in front. Therefore, to gain the maximum depth of field of a subject, the camera should be focused slightly behind the plane nearest the camera. The extent of the depth of field can be quickly checked on cameras which have a preview button. Occasionally, a limited depth of field may be preferred to emphasize one particular part of an insect, such as the jaws or the head.

Not only is focusing critical for close-ups, but also for moving subjects. As many insects are both small and mobile, a lens which has a fully automatic diaphragm (FAD) will ensure a higher proportion of sharp pictures than one with a preset diaphragm (PD) which has to be stopped down manually before an exposure is made. Moving subjects will also be followed more easily by using a pentaprism.

Stalking

Flowers are a good place to photograph the shape and colour of many day flying insects, such as bees, beetles, butterflies and flies. The way in which different insects feed, is described in the next chapter. Insects can be photographed by stalking them as they fly from flower to flower, or by patiently staying put and waiting for an insect to land on the flower on which the camera has been prefocused. My feeling is that the rate of success is probably about equal, but psychologically one *feels* as though more is achieved by stalking! The 'patient wait' method has the advantage that the most suitable camera viewpoint and background can be carefully selected. An uncluttered background—preferably with a contrasting tone to the plant and insect—is especially important when working in monochrome.

A medium long focus lens, such as a 135 mm used with some extension, is especially useful for stalking larger insects such as butterflies, since it permits a longer working distance than a standard lens so that the insect is less likely to be disturbed. On cool days butterflies will be less active and therefore less likely to be disturbed when approached.

Select the angle of the subject relative to the insect's body to suit the subject. For example, if the wing shape and venation, as well as the body coloration of the large hawker dragonflies is to be shown in a single picture, a dorsal view will be better than

Fig. 1.4 Small tortoiseshell *(Aglais urticae)* feeding on fleabane. Available light with close-up lens. ×4

a head-on or a side view. If resting butterflies, with folded wings, are taken from the side, the underwing pattern will be shown. From this viewpoint, a relatively small depth of field is needed to bring the entire butterfly into focus; so that it is particularly suitable when using available light on dull or windy days. Head-on pictures of butterflies feeding (Fig. 1.4) or of crickets and grasshoppers are more dramatic and provide pictorial relief in a monotonous series of lateral views.

Stalk insects by continuous slow movements rather than by hurried, jerky motions. As with all animals, some individual insects will be more wary than others, so start to expose sooner rather than later. The earlier, more distant shots will not be comparable with more detailed close-ups, but at least this technique ensures some record has been made. By careful field observations, the behaviour patterns of individual insects or even of a species as a whole, will become apparent. It may then be possible to anticipate the movements of some insects. The *Novoflex* rapid shooting bellows unit is useful for stalking insects. Fine adjustment to the focusing is easily made by pressure from a single hand on the pistol grip.

Setting up a tripod for photographing active flying insects in the field is seldom practical, since by the time all the adjustments have been made, the insect will have flown to the next plant. If some kind of camera support is preferred, then a monopod is both quick and easy to use. A tripod can, however, be useful for photographing nocturnal moths at rest during the daytime, and some caterpillars. One was used to take the speckled wood in Fig. 1.1 on a cold, dull June day.

Photography of macro subjects, especially insects, is very much a compromise between getting in as close as possible and not losing too much depth of field. To my mind, *in situ* photographs should convey more about an insect in its natural surroundings than a pin sharp studio portrait. If this is the aim, then it will not be essential to fill the frame with the insect. Examples which illustrate this point can be seen in Plates 1, 2, 3, 4, 5, 9, 10 and Figs. 1.1, 2.3.

Lighting

Photography of insects by means of available light, has its limitations—especially when using a slow colour film. But for those insects which have evolved their coloration or shape to

blend in with their surroundings (see Chapter 4), it is unlikely that even a single flashlight will exactly simulate the visual effect produced by the ambient lighting. Not only the tone of the subject, but the whole feeling it evokes in its surroundings, changes with the type and direction of the lighting.

A larger insect–such as a butterfly–resting on top of a plant, can sometimes be isolated from its surroundings by the use of natural light and shade (or by using flashlight). Such an example is shown in Plate 2. This green veined white butterfly was resting on the roadside verge amongst a confusion of flowers and grasses. I noticed that the hedge itself was in the shade, and so I asked a companion to carefully pick the single crosswort spike with the butterfly and to hold it clear of the verge. Nine times out of ten, the butterfly would have flown away, but this time I was lucky. The sunlight streaming through the wings is made even more effective against the dark back drop. Other examples of natural back lighting can be seen in Plates 1 and 5 and Figs. 1.3, 1.5 and 2.4.

Sometimes a slow shutter speed may suggest movement better than a fast flash. The 6-spot burnet moth in Plate 7, was deliberately photographed using a slow shutter speed so as to convey the wings beating prior to take off.

Flashlight Electronic flash can be extremely useful for photography in the field: not only for arresting movement (both by the insect and due to camera shake by the photographer) but also for increasing the depth of field and for isolating a subject from its surroundings. Flash may be essential when working in a dark wood or a cave.

When flash is used for photographing insects by stalking, it is preferable to have the flash and camera mounted on a single unit–such as an angle bracket–so that they can be moved in together towards the insect. Minutes of careful stalking can be wasted by suddenly thrusting a hand-held flash towards the insect. If a single flash is mounted on top of the camera it will illuminate the subject, but such frontal lighting is rather flat. Better modelling will be gained by moving the flash to one side of the camera. However, this angle can result in a distracting shadow appearing on the opposite side of the insect. Such a shadow can be softened by using a white card as a reflector or by a second, less powerful flash as a fill-in. It is possible to build up a single unit comprising the camera and two flash guns, by using right angle brackets and ball and socket heads for the fine adjustment of the flash-to-subject angle. If both flashes are

identical, the output of the fill-in flash can be reduced by covering it with a layer of tissue paper or with a white handkerchief. Some people favour using a third flash to illuminate the background, but such a set-up is too cumbersome and heavy to use for any length of time in the field.

Flashlight can also be used to backlight a subject – in a similar way to the sunlight in Plate 2. The flash will either have to be hand-held by an assistant, or attached to a tripod or a monopod. The placing of the flash in this position is critical, otherwise flare may result.

For electronic flash, use the X synchronization connecting socket on the camera. Double or even triple adapters can be used for triggering two or more flash units. A diaphragm or leaf shutter will synchronize with flash at any speed, whereas a focal plane shutter will synchronize only when the entire frame is exposed all at once. On some cameras this may be as slow as 1/30 second, but with most modern cameras synchronization can be achieved at 1/60 second or even 1/125 second. With electronic flash, it is the speed of the flash itself – not the shutter speed – which arrests the movement. However, on a sunny, windy day, if a slow shutter speed such as 1/30 second has to be used with a focal plane shutter, it is possible to get a blurred or double image caused by both the brief flashlight and the continuous sunlight registering. With a diaphragm shutter, a fast shutter speed can be used, and so the flashlight will override the effect of the sunlight.

The correct exposure when using flash for close-ups will have to be determined from a trial run of exposures. By keeping the filmstock, the magnification and the flash-to-subject distance constant, and only varying the aperture, the correct exposure for a subject of average contrast can be determined. Adjustments can then be made for darker or paler and for larger or smaller subjects. If the flash is fixed relative to the lens, it will automatically be brought nearer to the subject – as the camera is moved in closer. This compensates for a reduction in the light intensity as the amount of extension is increased, and in practice, it may be found that an identical aperture can be used for a range of magnifications.

Recording

It is always worth recording as much information about an insect as soon as possible after it has been photographed. The precise

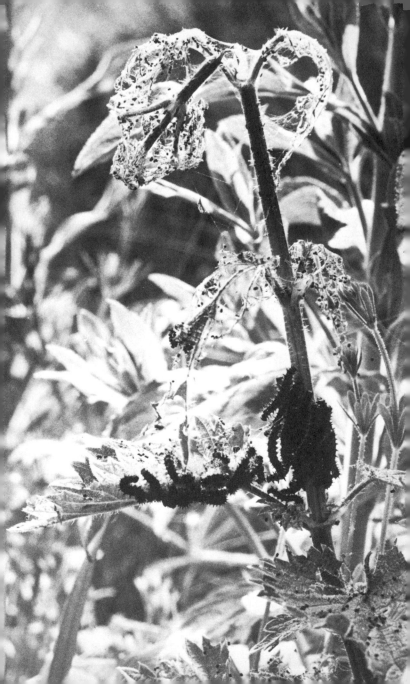

locality, the type of habitat, as well as the microhabitat, should of course be noted, in addition to any interesting behaviour. Since a period of several weeks may lapse before a colour film is completely exposed and returned from processing, the date should also be noted, as the life of some adult insects is surprisingly brief.

This data alone may still be insufficient to confirm the identification down to species level. The only certain way to confirm the identification of some insects is to collect them, so that parts can be examined under a lens or a microscope. However, since the main aim of the nature photographer is to record live insects in preference to ending their life prematurely in a killing bottle, no insect should be collected unless it is abundant and is to be used for precise identification—not discovered weeks or months later and then thrown out as a shrivelled corpse.

Fig. 1.5 Small tortoiseshell caterpillars (*Aglais urticae*) feeding on stinging nettle. Note eaten leaves and frass. Against the light in the field.

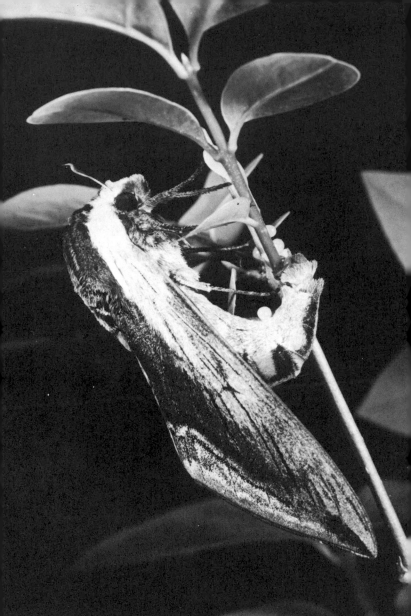

Fig. 2.1 Female privet hawk moth (*Sphinx ligustri*) laying eggs on privet. Studio with flash. $\times 1\frac{3}{4}$

More and more insect photographers are today moving away from the single-minded approach of flawless studio close-ups to the more difficult, but none the less rewarding approach of recording insects in action. Even a single photographic still can illustrate how an insect moves, or feeds, or courts.

Feeding

One of the easiest activities to photograph is feeding, since nearly all insects feed regularly (an exception is adult mayflies which do not feed at all) and usually alight or stop moving to feed. Some moths, including hawk moths, do not actually settle, but continue to hover as they feed.

The type of food eaten is reflected in the structure of the mouth-parts. Caterpillars, beetles, wasps, grasshoppers, crickets, dragonflies and termites use a pair of mandibles to munch their food; whereas butterflies and moths suck nectar via their slender tube – the proboscis. Bugs have piercing mouthparts for sucking up plant or animal juices (Fig. 6.1), while many flies have a broad pad-like proboscis for sucking up liquid food. Detailed macro-photographs comparing the mouthparts are more suitable subjects for studio photography, whereas many insects can be photographed as they feed in their natural surroundings.

Plant feeders Half of all types of insects eat green plants during some stage of their life history. Caterpillars – the larval stage of butterflies and moths – are amongst the easiest of subjects to photograph feeding (see Chapter 3).

Adult butterflies rarely return to a single fixed point to feed. It is, therefore, a matter of luck whether they select to alight on a particular flower on which the camera has been prefocused. Some flowers – such as the flat umbels of hogweed or wild parsnip – are especially attractive to a variety of butterflies, flies, bugs and beetles which visit them for the pollen or the nectar. Some wasps and dung flies visit the flowers to feed on the visiting insects. Therefore a wide range of insects can be photo-graphed on a single flower head in an afternoon.

Insects visiting flowers to feed on the nectar or the pollen may unconsciously ensure cross pollination takes place by transferring pollen from the stamens of one flower to the stigma of another.

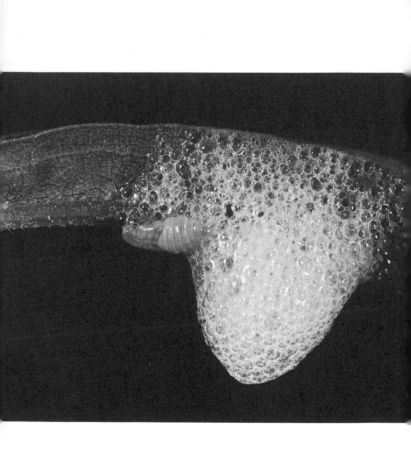

Fig. 2.2 Froghopper nymph emerging from protective froth or spittle.
Studio with flash.

Insects which visit only a single species or maybe a few closely related species of flowers, are termed *monotropic*; whereas insects which visit a wide range of flowers are referred to as *polytropic*.

Flowers which are cross-pollinated usually have some mechanism which prevents self-pollination from taking place. This may be due to different positions of the stamens and the stigma (as in the pin and the thrum-eyed primroses) or to different times of ripening. Thus flowers such as figwort and rowan in which the female part (stigma) matures before the male part (stamens) are termed *protogynous,* whereas *protandrous* flowers such as hogweed and fireweed produce ripe stamens first.

Insect-pollinated flowers show various adaptations to attract insects–in the form of colour, pattern or scent or a combination of these factors. Flowers which are pollinated by butterflies and moths are usually heavily scented, especially those which are visited at night. The night-scented catchfly opens its flowers and produces its scent only at night. Some butterflies, notably the purple emperor, white admiral and peacock feed on sap and can be found on damaged areas of tree trunks. They are also attracted to the smell of dung and manure.

The ability of many insects to perceive certain colours has for long fascinated scientists and not least bee keepers. Most two-winged flies (Diptera), butterflies and moths are able to distinguish blue colours from yellow colours, and many prefer one group to another. I have seen pearl bordered fritillaries in between feeding on blue bugle, repeatedly alight on my blue canvas shoes.

Bees see three main colours: yellow, blue and the short ultra-violet wavelengths which are invisible to us. Many flowers which appear uni-coloured to us, are seen to have a distinct ultra-violet pattern when photographed illuminated with an ultra-violet emitting light source and a filter placed over the camera lens to exclude all visible light rays. In addition, many flowers which exhibit patterns and guide marks visible to man, also have ultra-violet patterns. Several examples of ultra-violet patterns can also be found amongst insects themselves–especially amongst butterflies belonging to the family Pieridae. Fig. 5.4 compares the uni-toned visible coloration of a male brimstone butterfly with the ultra-violet pattern.

Insects which make rapid, fleeting visits to flowers–such as moths which hover as they feed, are much more difficult to photograph satisfactorily than an insect which systematically works each individual floret on a head of flowers. Photographs

of feeding butterflies and moths should clearly show the long slender uncoiled proboscis. Electronic flashlight is almost obligatory for detailed close-ups of small active insects, in order to achieve adequate depth of field as well as ensure the insect is not blurred. It is possible to photograph, by means of available light, butterflies (Fig. 1.4) and even bees (Plate 1) and wasps feeding, providing a fairly fast film is used when the ambient lighting is low. Problems which arise when using direct flashlight include the comparative over-exposure of white flowers and lack of differentiation between black parts of the insect and the unlit distant background. Bounced flashlight will provide a more subtle lighting for white flowers.

When flashlight is used in the field for insect close-ups it will usually be the major light source. It can also be used in sunlight

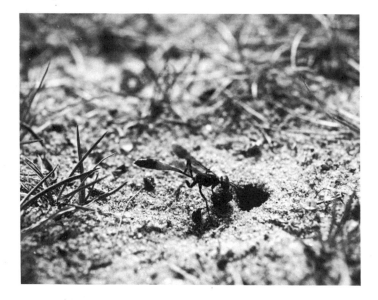

Fig. 2.3 Sand digger wasp (*Ammophila sabulosa*) plugging burrow hole. Available light and close-up lens.

to fill-in shadows, in what is known as a synchro-sunlight shot. The camera is set as for an exposure in the sunlight. The flash is then moved back to the position where it will light the subject correctly for the aperture which has been selected.

In addition to the external plant feeders are the internal feeders, which include wood borers, leaf miners and gall formers. Most of these are very small insects which are therefore more suitable as subjects for photography indoors. Unless they are in their dispersal phase, (adult beetles and gall wasps), the insects will have to be revealed by dissecting the plant tissue.

Animal feeders Many insects feed on animals—including other insects. Insect predators which devour pests are clearly beneficial to man. Well known examples are the ladybird· and the lacewing—both of which feed on aphids (Plates 12 and 15). Some natural insect predators have been introduced into areas as a means of biologically controlling a pest species.

Carabid beetles which are equipped with a stout pair of jaws are clearly carnivorous; but the huge antler-like jaws sported by the male stag beetle are solely a secondary sexual characteristic. Unlike grasshoppers to which they are related, many crickets feed on insects—even other crickets. Many insect predators do not have jaws; the carnivorous bugs—including the assassin bug—feed by piercing and sucking juices from their animal prey.

Although spiders are not insects, they so often occur with them that their photography can be briefly mentioned here. A web spider feeding on prey trapped in its web is a much easier subject for taking a series of photographs in the field than a highly mobile carabid beetle. Crab spiders, on the other hand, blend in so well with their surroundings that they simply lie in wait for a visiting insect. In taking Fig. 4.1 it was the dark insect rather than the spider which first caught my eye amongst the white blossom.

If the burrow made by a solitary hunting or digger wasp is discovered (Fig. 2.3), the wasp may be seen returning with its prey. Each kind of hunting wasp selects its prey which it paralyzes with its sting and pushes into the hole where it will provide food for its developing offspring. Some hunt only spiders while others hunt caterpillars.

The actions of many carnivorous insects are rapid, so flashlight will be useful for photographing them—although occasionally the flash may disturb their feeding.

Pests and parasites Compared with hawk moths and dragonflies, insect pests might seem hardly worth wasting time and film on. However, they do provide yet another category for making a

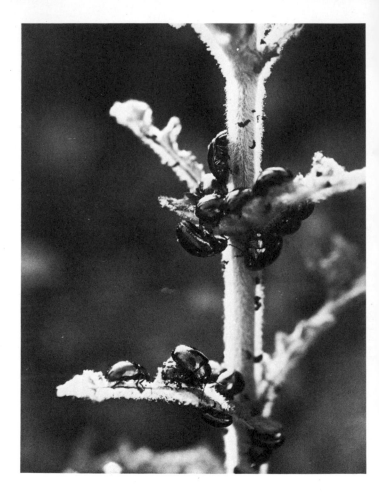

Fig. 2.4 Mint beetles *(Chrysolina menthastri)* on Bowle's mint. Against the light late in the day. Camera on tripod.

collection of photographs of unrelated insects, and pictures of them are of value to gardeners and horticulturalists. A species may be a pest in one country, yet be a rarity in another. Large numbers of a single species within a small area may prove noxious, destructive or just troublesome.

Locusts are a well known example of how a relatively small animal–present in vast numbers–can decimate crops. But even some species of caterpillars can completely defoliate trees when they reach pest proportions. I have seen areas of evergreen cork oaks in South Spain, stripped of all their leaves by gipsy moth caterpillars. At the edge of this central brown zone, the caterpillars could be heard munching furiously and all too frequently the odd one dropped down onto us as we walked beneath the trees.

On a much smaller scale, metallic green mint beetles have built up their population in our garden over the last three years to such an extent that they now munch their way steadily through the entire mint and balm crop in our herb garden (Fig. 2.4), because we could not bring ourselves to kill such an attractive insect!

Unlike insect predators, which feed on many prey individuals, insect parasites require only one individual host in which to develop. Parasitic insects attack a variety of hosts–including other insects and even man. Any of the stages in an insect's life history–including the eggs–may be parasitized. Insect breeders will be aware of the ichneumon flies which occasionally emerge from a pupa in place of a butterfly or moth. These, like the warble fly and toad fly are examples of parasites which live inside their hosts for part of their life history. But by far the most conspicuous parasites are those which live externally– either temporarily or permanently–on their host. Such parasites include fleas, mosquitoes, horse flies, sheep keds and lice. Ticks, incidentally, have four pairs of legs and are classified with spiders in the Arachnida.

When photographing pests and parasites, the aim should be to show the animal in conjunction with its food or its host: pests causing damage and parasites either feeding or emerging from their host. Some female parasitic ichneumon flies are able to detect their host larvae in their burrows inside tree trunks. They use their long ovipositor to drill down through the wood to reach their host. The easiest way to photograph gall wasps is to collect the mature galls and to breed out the small wasps.

Plate 2 Green veined white *(Pieris napi)* on crosswort. Photographed against the light with a macro lens. ×2½

Attracting insects

Several techniques can be used to attract certain insects for photography.

Flowers Adult butterflies can be attracted into gardens in which highly scented, nectar producing flowers are grown–flowers such as buddleia, honeysuckle, stocks, Michaelmas daisies, lavender, sweet rocket and *Sedum* are preferred to modern roses and dahlias. In addition, stinging nettles are worth cultivating as the food plant for several species of caterpillars (see Fig. 1.5).

Baiting Windfallen fruit naturally attracts both butterflies and wasps, and any ripe fruit can be intentionally placed on a compost heap or a lawn as bait. Pitfall traps can be made for beetles by baiting jam jars with carrion and sinking them into the ground. Cover the top with coarse netting to prevent small mammals falling in. Animal corpses, including birds, small mammals and even fish, will attract burying beetles–providing the corpses are pegged down to prevent larger animals removing them.

Sugaring is an old method used for attracting night flying moths. A mixture of 1 lb. black treacle, $\frac{1}{2}$ pint of brown ale and a tot of rum is boiled and then painted on trunks and fence posts at head height. Knowing the best places to sugar and selecting the optimum weather conditions are both critical. Humid, overcast nights are preferable to clear, moonlit nights. On windy nights, the smell of the mixture soon becomes dispersed. Moths which come to sugar can either be photographed *in situ* with flashlight (a torch will be needed for focusing) or collected for photography inside. Repeated sugaring is not recommended since it makes the area look unsightly, it provides an easy supply of food for birds and it may result in other crawling insects becoming stuck and killed.

Light sources Most moths are attracted to light–even a household bulb shining through an uncurtained window–to which they finally spiral in towards. Street lamps–especially the green mercury-vapour lamps–will attract moths, so will a 'Butagaz' camping light. A white sheet laid on the ground under these light sources will make it much easier to see any moth falling to the ground.

Entomologists use the more powerful ultra-violet emitting mercury vapour lamp for attracting moths from a much wider radius. The lamp can be used with a white sheet or board, and the moths netted as they fly in, but more often it is combined with a trap–known as a Robinson light trap–which collects the moths

Fig. 2.5 Silver Y moth (*Plusia gama*) taking off from knapweed. Flashlight in field. ×2½

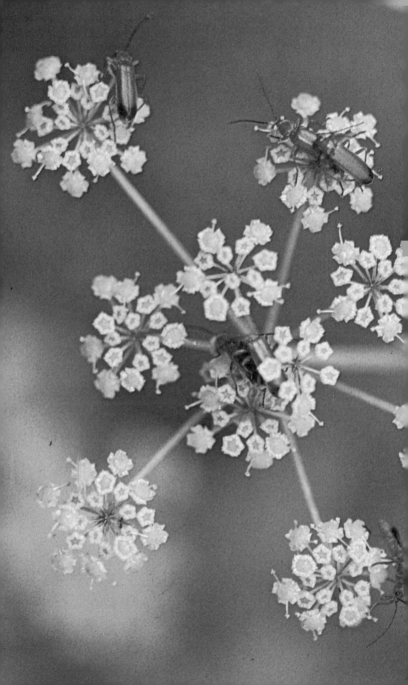

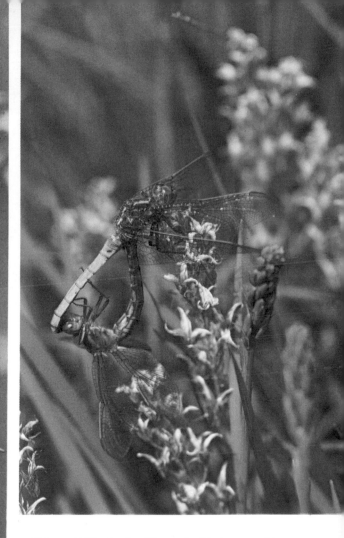

Plate 3 Soldier beetles *(Rhagonycha fulva)*, some pairing, on wild parsnip. Diffuse natural lighting, with camera on tripod and a macro lens. × 3 (opposite).

Plate 4 Dragonflies *(Orthetrum coerulescens)* pairing. Blue male holding female by her head. Available light with macro lens.

as they fall down through the funnel at the base of the lamp. Filling the trap with crumpled newspaper or empty egg cartons, provides plenty of hideouts for the moths to crawl away from the light. Light from mercury vapour lamps will damage human eyes, and so should not be looked at directly unless protective goggles are worn. As with sugaring, light trapping should be done sparingly and only a few specimens kept for photography. Not all moths attracted to the light may enter the trap, so that repeated light trappings can result in a reduction in the moth population, through birds coming at dawn and eating the moths outside the trap.

Assembling Certain male moths can be attracted by the scent of an unmated female. The best way of obtaining a virgin moth is to breed it in captivity. Place her in a container covered with muslin and leave it in a suitable locality outside or beside an open window. If the males have emerged from the natural population, there is a good chance that some will find the female. Emperor moths are particularly effective – a single female has been known to assemble several dozen males! By obtaining even a single male, photographs can then be taken of the pairing and of the various stages in the life history, including the eggs, caterpillars and pupae.

Flight

The ability to fly, enables insects to feed and breed in new areas, as well as to reach a mate or to escape from predators. Flight photography can provide useful information about an important aspect of many insects' behaviour. The speed at which some insects fly (over 15 miles per hour for some dragonflies) and their rate of wing beat (15,000 per minute for the honeybee), makes it impractical to photograph them in flight with a conventional camera and electronic flash. Flight pictures of fast flying insects can be achieved only by using light tripping beams and high speed electronic flash. Since these techniques are beyond the scope of the average photographer, they will not be described here. However, it is quite possible to photograph slower flying insects in flight or as they are about to take off, by using electronic flash or a fast film. As already mentioned on page 14, deliberate use of a slow shutter speed (Plate 7) can be effective for suggesting movement – providing the subject is carefully selected. The best times for attempting flight pictures of bees, butterflies, moths and beetles are when they are just taking off (Fig. 2.5) or alighting on a plant. Do not be deterred if a high proportion of frames are

often wasted; since an element of luck is involved in solving all the problems in a single shot–problems such as critical focusing, optimum depth of field and avoidance of confusing background shapes or colours. Windy days create extra difficulties, since the insect may be blown out of its apparent path without warning. The easiest technique is to select the required magnification and to focus the camera by moving it (together with the flash) in towards the insect and then release the shutter as soon as part of the insect appears sharp. Providing a small aperture is used, the rest of the insect is likely to be brought into focus.

Breeding

The time which insects spend courting, mating and egg laying is brief compared with the time they spend feeding and so photography of these activities is much more unpredictable. Some insects may remain paired together for several hours or even days. The orange soldier beetles which feed on flat heads of hogweed and wild parsnip, are almost always pairing (Plate 3). Even if butterflies or moths are found pairing in an unattractive setting, it is worth taking at least a few pictures, since they are very likely to separate when handled.

The courtship display of the grayling butterfly presents a decided challenge for a photo sequence. The male first pursues the female. Then bows to her and clasps her antennae in his forewings before he finally copulates with her. Courtship is often an elaborate sequence of ritual behaviour, that serves to ensure the male and the female are the same species before they mate.

Pictures of insects ovipositing can be taken both in the field and indoors. Female dragonflies can often be seen laying their eggs in water at the right time of year. Some butterflies lay individual eggs amongst the food plants of the caterpillar, while others lay their eggs in compact groups. The female privet hawk moth illustrated in Fig. 2.1 laid her clump of eggs while quite free to roam, on a spray of privet on our kitchen table at midnight. Some of her progeny are shown in Fig. 3.2.

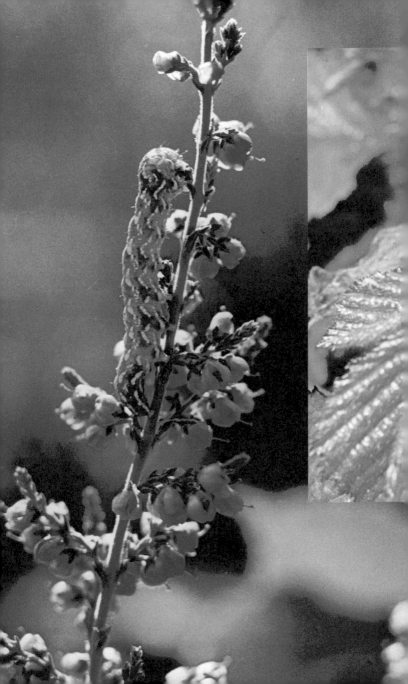

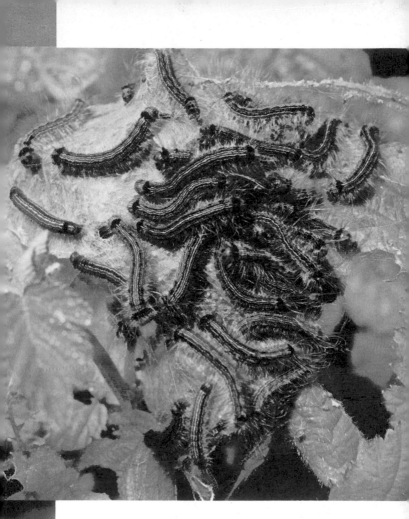

Plate 5 Beautiful yellow underwing caterpillar *(Anarta myrtilli)* feeding on ling *(Calluna vulgaris)*. Against the light with macro lens. × 3 (opposite).

Plate 6 Gregarious lackey moth caterpillars *(Malacosoma neustria)* feeding on bramble. Flashlight in the field.

Fig. 3.1 Interior of wasp nest show
uncapped cells with eggs and
larvae, capped cells and wasp
emerging from one cell.
Studio with flash. × 5

The immature stages of insects which include eggs, larvae and pupae, extend even further the potential range of subjects available for photography. Much more will be learnt about insect life histories, by photographing all stages, rather than concentrating solely on portraits of adults.

Life histories

Very few insects give birth to live offspring; an exception is the summer generation of aphids (Plate 11). Most insects lay eggs which hatch into larvae. Insects can be divided into two groups based on the development of their larvae. In the Exopterygota the larva or nymph resembles the adult form. It grows gradually developing wings on the outside of its body, by a series of moults. Examples of this type of insect are bugs, cockroaches, mayflies, earwigs, crickets and grasshoppers.

$$\text{Egg} \longrightarrow \text{nymph} \xrightarrow[\text{several moults}]{\text{by an incomplete metamorphosis}} \text{adult}$$

In the Endopterygota, the larvae which are totally unlike the adults, usually feed on quite different food from them. When fully grown the larva enters a resting, non-feeding stage known as a pupa, during which time it undergoes a complete metamorphosis as its body becomes totally reorganized. The wings develop internally and expand when the adult or imago emerges. The life history of a butterfly can be summarized thus:

$$\text{Egg} \longrightarrow \underset{\text{(larva)}}{\text{caterpillar}} \longrightarrow \underset{\text{(pupa)}}{\text{chrysalis}} \longrightarrow \underset{\text{(imago)}}{\text{adult}}$$

Other endopterygote insects are moths, caddis flies, two-winged flies, bees, wasps and beetles.

Eggs The place to look for the eggs of an insect is close to the food which the larva eats. Butterflies and moths which have plant-eating larvae, usually lay their eggs on the food plant, often beneath the leaves. Many insect eggs are very small and so are hard to find in the field, unless they are laid in batches – often in a beautifully regular pattern. Eggs are most easily obtained by confining a mated female to a breeding cage. Once laid, some eggs are remarkably resistent to extreme weather conditions, surviving the winter exposed on bare twigs.

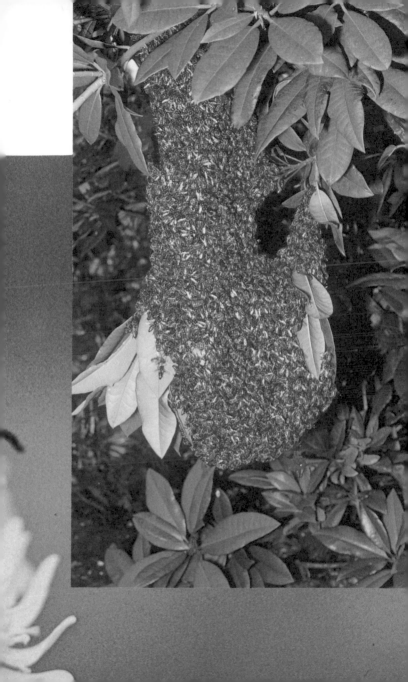

Insect eggs in general make excellent subjects for macro-photography indoors. If their surface is textured, it should be shown in a photograph, for example by using grazed lighting. But unless some reflector is used to fill-in on the opposite side, only one side will be lit adequately. Oblique bounced lighting was used for the privet hawk moth eggs and caterpillars (Fig. 3.2) so that slight modelling helped to distinguish the green eggs against the green leaf, without too conspicuous a highlight appearing on the shiny egg shells. Clusters of creamy house fly and blow fly eggs (on carrion) or of brown alder fly eggs (on waterside vegetation) are conspicuous enough to be photographed *in situ* with extension tubes.

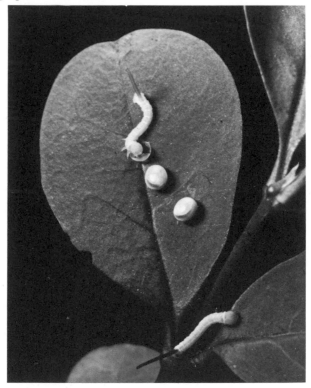

Fig. 3.2 Privet hawk moth caterpillar *(Sphinx ligustri)* eating its egg shell seconds after hatching. Studio, bounced flash. × 3 M

Larvae When the larva or nymph is ready to leave its egg, it either pushes or chews its way out. Do not remove the larvae from their egg shells, since it is essential for some species to eat them (Fig. 3.2). Larvae of flies and some beetles, which hatch out amongst their food supply, are legless and known as grubs or maggots. Butterfly and moth larvae (caterpillars) which have to go in search of food, possess three pairs of true legs near the front end and usually four pairs of false legs or claspers near the hind end of the body. A large family of moths known as the geometers (ground measurers) have only two pairs of claspers. They move by arching and looping their bodies instead of crawling, and are referred to as 'loopers' (or in America as 'measuring worms'). This looping motion is quite characteristic. Some loopers resemble a twig; clinging on by their back pair of claspers they rest with the head supported by a silk thread and the body held stiffly at an angle to the branch. Green pine loopers resemble the pine needles on which they feed, by lying along their length (Fig. 4.4).

Solitary caterpillars—especially those which mimic twigs—are much more difficult to spot in the field than gregarious caterpillars which feed *en masse* (Plate 6 and Fig. 1.5). Caterpillars remain on or near their food plant until they are ready to pupate, so by knowing what they feed on and the time of year when they occur, they can be tracked down.

As the caterpillar feeds it grows—not continuously, but in stages—by shedding its outer skin (moulting) periodically. The stages between the moults are known as instars. Different instars obviously differ in size and each may be quite distinctly coloured. Since reference books usually illustrate only the final instar, identification of young caterpillars may be possible only by breeding them through all their instars. Full-grown caterpillars are obviously easier to spot in the field than newly hatched ones. The elephant hawk moth caterpillar in Plate 16 resting on top of a high plant was very conspicuous. The dry pellets produced by caterpillars are known as frass. The large frass of full-grown hawk moth caterpillars is often visible on the ground—a clue that the caterpillars must be feeding amongst the branches above. Pest species (page 23) can be detected by their widespread damage and defoliation.

The food plant may be a vital factor in confirming identification of an insect, so the aim should be to show a leaf or a flower as well as the caterpillar in the picture. It is also worth noting any distinctive feature of the plant as a whole. Many caterpillars can

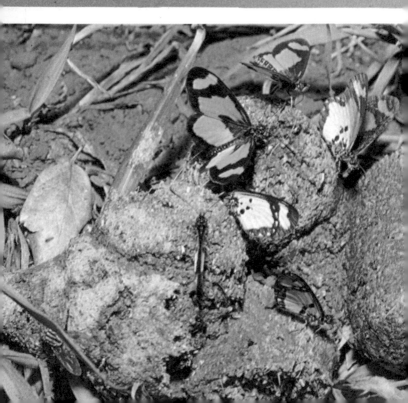

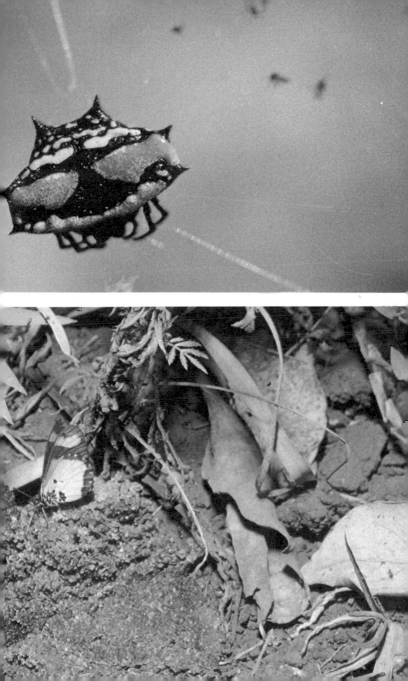

be photographed feeding in the field by means of available light—as was the case with Plate 5 and Fig. 1.5. Flashlight is useful, however, for detailed close-up photographs of the mouth-parts or of newly hatched larvae, which may have to be taken in the studio.

Try, if possible, to vary the direction of the lighting—back lighting is particularly effective for hairy caterpillars (especially tussock moth caterpillars). These should be handled with care, since their hairs are easily transferred from hands to face, where they can produce on some people an irritating reaction—known as urticaria. Be careful not to brush against or to suddenly move the plants on which caterpillars are feeding, since the instinctive reaction of many species is to drop to the ground or to lower themselves on gossamer threads.

Very young caterpillars feed by scraping the surface of leaves, but as they grow they munch right through a leaf. The three pairs of true legs grip either side of the leaf so that the jaws attack the leaf edge on—repeatedly eating out semi-circular portions. Privet

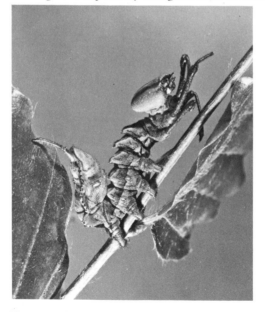

Fig. 3.3 Lobster moth caterpillar *(Stauropus fagi)* showing alarm posture. Studio and flash.

hawk moth caterpillars kept in captivity can be seen systematically eating down one side of a privet leaf, then the other, before moving on to the next leaf and repeating the procedure.

In the autumn, many caterpillars become more conspicuous as they crawl down from their food plants and walk across the ground in search of a suitable place to pupate. At this stage, the caterpillars may no longer feed and if their claspers have become withered, they cannot support their own weight on a stem or a leaf.

Many sawfly larvae are gregarious feeders and can cause extensive damage to plants–one of the best known being the gooseberry sawfly. Sawfly larvae scrape away the surface of leaves so that they become reduced to bare skeletons. They look very similar to butterfly or moth caterpillars, but they have an extra pair of claspers. When disturbed, they rear up the front end of their body in a characteristic S-shaped curve.

Pupae The pupa is the penultimate instar of insects which have a complete metamorphosis. Silkworm moth caterpillars spin elaborate cocoons on vegetation above the ground. Butterfly caterpillars pupate after they have either anchored themselves by their tails with a girdle of silk around the front end of their bodies (brimstone, whites and swallowtail butterflies) or hung themselves upside down by their tails (vanessid butterflies). Once attached, the larval skin is gradually shed as the pupal skin forms underneath. Caterpillars of many moths crawl underground to pupate. These pupae can be dug out beneath the trees or shrubs on which the caterpillars feed. Pupa digging is best done in the autumn before the winter frosts. If a live pupa is held between fingers, the tail end will waggle from side to side.

Pupae do not feed, and move to a very limited extent. The only scope for action is the hatching. However, a pupa picture does complete the series of pictures illustrating the life history from egg, through larva, to adult. Even pupae are of different types, those of butterflies and moths develop their appendages inside the outer casing. Whereas pupae of bees and wasps have free appendages clearly distinguishable from the body of the pupa. They develop in cells inside the nests (Fig. 3.1) and so can be photographed only after part of the cell walls have been removed.

Plate 11 Aphids giving birth to live offspring in summer. Studio with flash.
×9 M

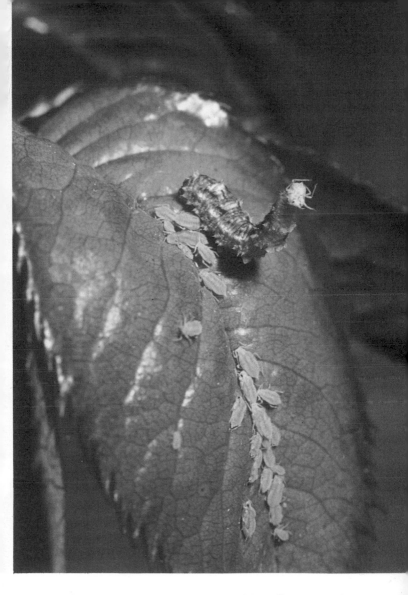

Plate 12 Hoverfly larva feeding on aphid. Single flash in studio. × 5

Fig. 4.1 Crab spider *(Misumena vatia)* blends in amongst hawt flowers and thereby preys on visiting insects. Available lig field.

CHAPTER 4 COLOUR AND SURVIVAL

Many insects fall prey to other insects as well as birds and other animals. In spite of this predation, some species–such as aphids–survive because of the large numbers of offspring they produce. Other, less prolific insects, have evolved special adaptations for survival against predators. Some make themselves inconspicuous by blending in with their surroundings. Many poisonous or unpleasant tasting insects advertise their presence with bold warning colours and a minority of harmless insects survive by mimicking these noxious ones.

Camouflage

Camouflage coloration is widespread amongst insects. Its success lies in the combination of behavioural patterns with body design and colour. Camouflage may be achieved in various ways, but it is effective only when the insect is viewed in its natural surroundings. It breaks down immediately the insect is transferred to a uni-toned background.

Photographing insect camouflage is not straightforward, since it requires a critical approach to both lighting and picture composition. The most successful camouflage pictures are those which are taken *in situ*, so that they show the insect in relation to its surroundings. The background should cover a larger area than the insect itself (Fig. 4.2). Close-up pictures of moths resting on a trunk with a few millimetres of bark visible on either side of each wing are ineffective at illustrating the effectiveness of the camouflage.

Camouflage pictures taken in a studio are rarely convincing. A background of leaf litter, however carefully scattered, never has the same appearance as a genuine forest floor, and the lighting and shadows never quite simulate those derived from natural lighting. Direct lighting by flashlight–however carefully positioned–will cast some shadow. The basic rule of camouflage is not-to appear to be what you are, and shadow patterns are often instantly recognizable. So, for camouflage to be completely successful, it must be combined with concealment of the body shadow. Insects which have flat bodies cast no discernible shadow and so merge in well with their substrate. Projections along the sides of caterpillars help to break up their body outline and shadow when at rest. Also, hairs beneath legs help to mask leg shadows.

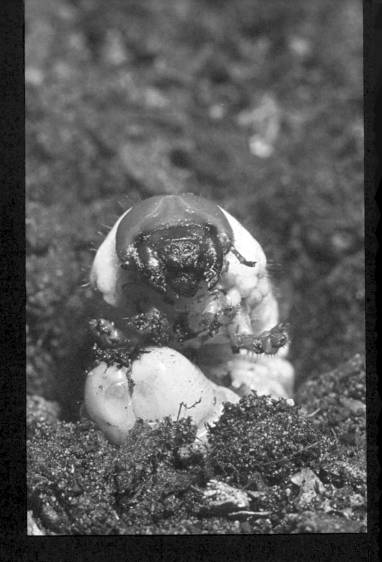

Plate 13 Stag beetle larva *(Lucanus cervus)* Flashlight in studio. × 3

Plate 14 Assam silkmoth caterpillar *(Antheraea pernyi)* feeding on oak
leaves. Studio with flash.

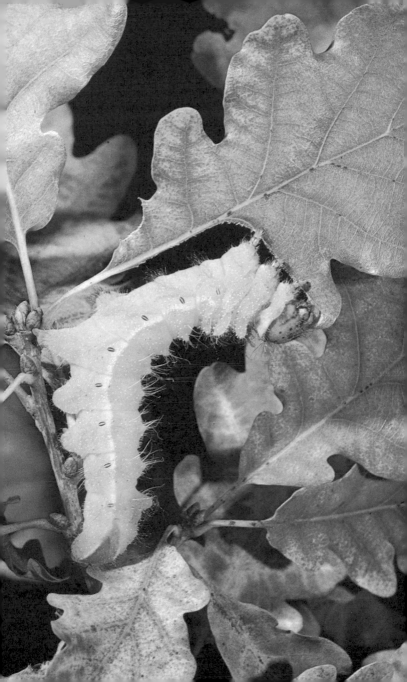

Cryptic coloration Many moths and also butterflies are cryptically coloured. Night flying moths are often coloured a mottled brown, so as to blend in with tree trunks when they rest during the day. Some are a mottled green or grey colour, blending in with the epiphytic lichens that grow on the trunks. Moths which emerge in the temperate late summer or autumn are typically yellow or brown coloured and so blend in with autumn leaves.

Moths at rest can be photographed using a long exposure with the camera mounted on a tripod. If an insect has to be photographed indoors, then the most suitable type of lighting for not spoiling camouflage is either a single light source from above the insect, or a general diffuse light. Resting butterflies typically close their wings and so it is the underwings which are cryptically coloured. The grayling blends perfectly with dry grass or stony ground, for when it alights the more conspicuous forewings are drawn down beneath the hindwings. The butterfly then turns its body towards the sun and leans over, flattening its wings towards the ground so that they cast no discernible shadow, illustrating the importance of behaviour patterns in effective camouflage. The green hairstreak also tilts its body against its usual background of green leaves—so that it blends in with the vegetation.

Grasshoppers are cryptically coloured—those which feed on grass tend to be green, but many are brown or mottled, merging with the shadow patterns cast by the criss-crossing stems.

The peppered moth is a classic example of the way in which the interaction of a predator and its prey results in natural selection. Before 1850 this moth was usually pale coloured with minute black speckling, a coloration which merges in perfectly with lichen covered trunks. Then, an odd black (or melanistic) form was reported from Manchester. Gradually, as the buildings and trees became progressively blackened by smoke and grime and all the lichens killed, the proportion of black to pale forms increased. By 1900 99% of the peppered moths in Manchester were the black form—a change which occurred within a lifetime. By releasing large numbers of both forms in a rural area and an industrial area, it was found that birds detected and ate more of the pale forms in the smoke-ridden area, whereas in the country more black forms were detected and eaten. Since the introduction of smokeless zones, more pale forms are beginning to appear again in industrial areas.

Some caterpillars synthesize their own colour pigments, while others acquire their colours from their food. Some green

Fig. 4.2 Garden carpet moth *(Xanthorhoe fluctata)* resting on silver birch trunk. Available light in field.

Plate 15 7-spot ladybird *(Coccinella 7-punctata)* feeding on aphid. Studio with one direct flash and one bounced flash. Bellows ×5 M

Plate 16 **Elephant hawk moth caterpillar** *(Deilephila elpenor)* **displaying eye marks. Available light in field.**

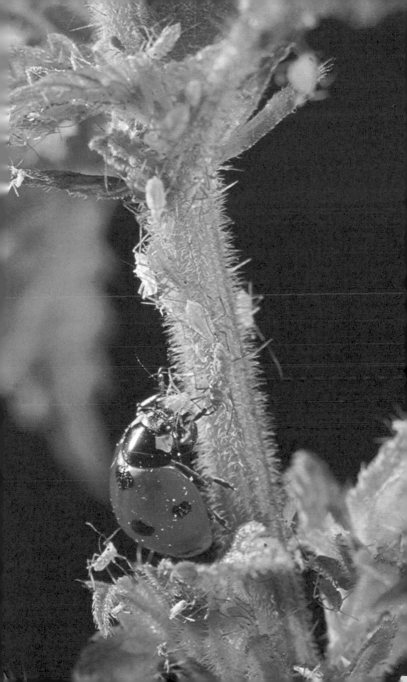

caterpillars are coloured by a modified form of chlorophyll which is stable in sunlight. When eyed hawk moth caterpillars hatch they appear green before they have fed, as a green pigment is present in the eggs. Some pug moth caterpillars blend perfectly with the flowers they eat, by concentrating the flower pigments. For example, the toadflax pug caterpillar is yellow and the ling pug is pinkish.

Some larger insects may also have additional marks which disrupt or break up their body outline. If the colour and tone of some markings blend in with the surroundings, it is difficult to pick out where the insect ends and where the background begins. Alternatively, some markings may be more conspicuous than the complete insect, so that unrecognizable patches stand out – distracting attention from the insect's shape as a whole. This principle of disruptive markings was used during wartime to disguise buildings and tanks. A conspicuous stripe may serve to visually break an insect's shape into two apparently unrelated parts. Alternatively they may integrate the insect's appearance with its background. Moths which have wing markings with lines running at right angles to the body – from one wing to the other, come to rest on trunks in a horizontal position, so that these lines coincide with the longitudinal bark pattern.

Countershading When a uniformly coloured object is illuminated from above it will appear light above and dark below. Large caterpillars which naturally rest clinging upside down beneath branches are a shade darker on their underside, so that when lit by available lighting, they appear uniformly coloured. This coloration – known as countershading – can be seen in the eyed hawk moth and also in the silkmoth caterpillars. The effectiveness is further enhanced in the green eyed hawk moth caterpillar by the diagonal markings on each side of the body which resemble leaf veins. The purple emperor moth caterpillar habitually rests in a vertical position and is darkest at its head end.

Once again, photography in the field by means of available light is the only way of ensuring that a picture records the way in which countershading aids in the survival of the insect. A caterpillar lit by more than a single light source from above or placed in any position other than the normal resting one, immediately becomes conspicuous. It is essential before taking any camouflage picture, to check that the insect is behaving naturally and is in its proper ecological context.

Warning coloration

Insects which exhibit warning coloration are usually active during the daytime when they can be seen most clearly. They rest in conspicuous places or aggregate together (gregarious caterpillars). They may use sound or smell to draw attention to themselves. Associated with warning colours are toxic or noxious secretions, which may be produced from the mouth, wing veins, leg joints or even antennae.

Insects which sting, or which smell or taste obnoxious make themselves as conspicuous as possible, so that predators soon learn to leave them well alone. This blatant advertisement—known as warning coloration—is by no means restricted to insects. Throughout the animal kingdom, examples can be found which combine two or more contrasting colours—colours such as white, yellow, orange, red and black.

Warning coloration occurs in caterpillars, pupae as well as adults; all stages in the life history of the magpie moth exhibit warning coloration. Other examples amongst Lepidoptera include the cinnabar moth (black and red) and its caterpillars (black and yellow—see jacket); the tiger moths (often reinforced by flashing more brightly coloured underwings) and the monarch butterflies. Monarchs are toxic insects which store heart poisons from the milkweeds on which they feed. Other insects manufacture their own toxins. Some hairy or spiny caterpillars inject poisons via their hollow hairs or spines. They may also incorporate these hairs into their cocoons as a means of protection.

The combination of black and yellow coloration occurs in bees, hornets and wasps, which are equipped with poisonous stings. The familiar red and black, and black and yellow ladybirds, are beetles which show warning coloration, and when handled they produce an unpleasant smelling orange secretion.

Since the principle of warning coloration is the exact opposite of camouflage, photographs of brightly coloured insects should also aim to make them look as conspicuous as possible. Quite different techniques can be used—including the use of flashlight to isolate an insect from an unlit background, and photography under controlled conditions. But, as with camouflage pictures, it is always useful to include at least some part of an insect's

Plate 18 Light emerald caterpillar *(Campoea margaritata)*
resembles beech twig. Studio with flash. ×2

Plate 17 Wasp beetle *(Clytus arietis)* mimics warning coloration of wasp. Dual source oblique lighting in studio. Bellows ×15 M

Fig. 4.3 Bull's-eye moth *(Automeris io)*. Studio, dual source oblique flash. × 1½
Above: at rest.
Below: displaying eye spots on underwings.

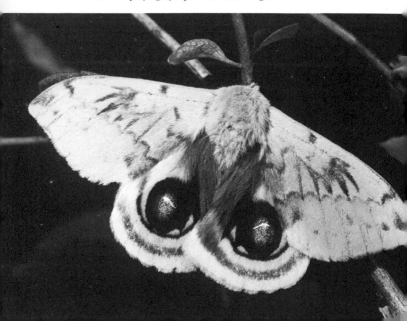

immediate surroundings, to convey its natural habitat. Examples of warning coloration included in this book can be seen on the jacket and in Plates 7, 15 and 17.

Some harmless cryptically coloured insects, if discovered by a predator, can transform themselves into an apparently frightening object. These shock tactics may take the form of flashing brightly coloured underwings (tiger moths, underwings and tropical grasshoppers), exposing false eyes (elephant hawk moth caterpillar (Plate 16), peacock butterfly, eyed hawk moth, bull's eye moth – Fig. 4.3) or adopting threatening postures (puss moth caterpillar). Photography illustrating the significance of flash coloration and of eye spots is best done by taking a pair of pictures; the first showing the insect at rest, the second it displaying. Such comparative pairs of pictures will illustrate the impact of the transformation better than a single picture of the display.

Mimicry

Yet another way in which insects survive in the wild is by mimicking either natural inanimate objects (disguise) or noxious insects. Unlike camouflaged insects, disguised insects often have a very conspicuous outline, shape and colour; their survival depends on their colour and form being indistinguishable from the object it mimics.

Insect disguise may take the form of twigs (stick insects and geometrid caterpillars), of leaves (lappet moth, angle shades moth and leaf insect), or thorns (treehoppers) or even of bird droppings (young alder moth caterpillar). Both brown fallen leaves as well as green living leaves are mimicked by insects. The extent of the mimicry often extends far beyond the general shape and coloration, to include the venation pattern and even insect damage. As with camouflaged insects, photographs illustrating disguise are best taken *in situ* – if the insect can be spotted in the first place!

A minority of harmless insects mimic the warning colours of toxic insects. As the name suggests, the wasp beetle (Plate 17) mimics wasps, while hoverflies mimic bees both in their coloration and by buzzing.

When a harmless insect mimics the warning coloration of a toxic insect, it is known as Batesian mimicry; whereas when different species (all of which are toxic) mimic each other, this is known as Müllerian mimicry. For Batesian mimicry to work there must be far fewer mimics than models, and also both the mimics and their models must be active at the same time.

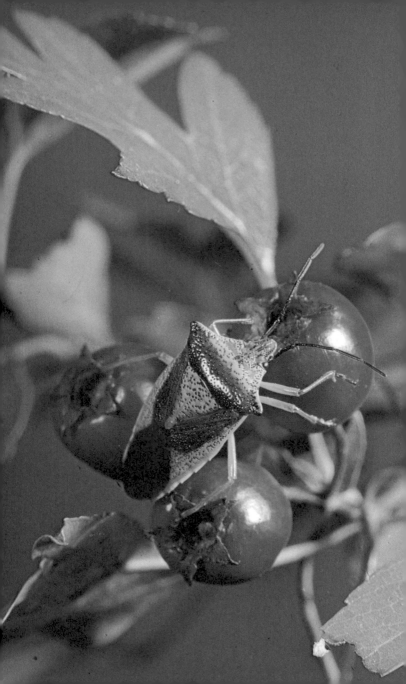

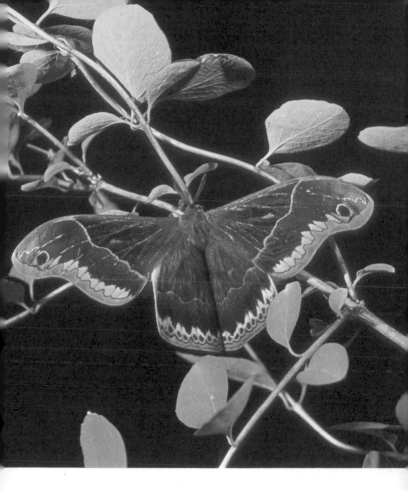

Plate 20 Cherry moth *(Callosamia promethea)* bred for photography. In studio
with flash.

Plate 19 Hawthorn shield bug *(Acanthosoma haemorrhoidale)* on hawthorn. Flash
in studio. × 3½ (opposite).

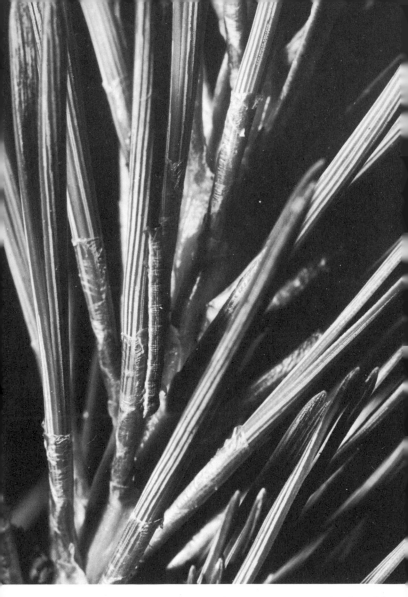

Fig. 4.4 Caterpillar of pine looper moth *(Bupalus piniaria)* mimics pine needle. Studio, single oblique flash. × 3½

What is particularly interesting is the way in which some insects have evolved quite different colorations and forms in order to increase their chance of survival during each stage of their life history. For example, the adult buff tip moth resembles a broken twig, while its gregarious caterpillars sport a conspicuous black and yellow warning coloration. Caterpillars of geometrid moths mimic twigs (Plate 18), while the pupae resemble the soil coloration and the adult moths the pattern of the bark on which they rest.

Adaptive coloration of insects is a particularly suitable subject for recording on colour film. Once examples have been found amongst insects, more will be found amongst other animal groups.

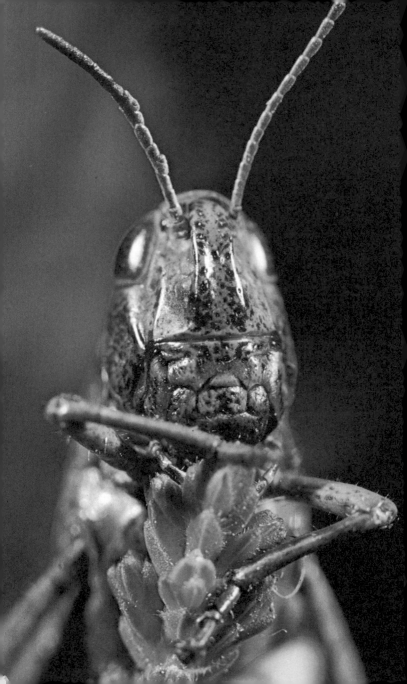

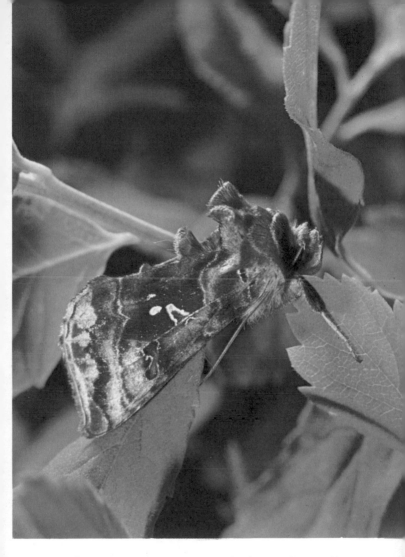

Plate 21 Field grasshopper *(Chorthippus brunneus)* head-on. Dual source oblique lighting in studio. × 16 M (opposite).

Plate 22 Beautiful golden Y moth *(Plusia pulchrina)*. Studio, two oblique flash, one from in front and one behind moth. × 3½

Fig. 5.1 Swallowtail butterfly *(Papilio machaon)* bred for photography. Studio with flash.

Detailed close-ups of insects are easier to photograph indoors, since the lighting can be controlled and the background selected. Subjects can be collected or bred for studio photography. In addition to the various ways of attracting insects already described in Chapter 2, there are a variety of techniques for collecting insects.

Collecting

No insect should be collected unless it is abundant in the area. Studying insects in captivity, however, is one way of getting to know their characteristics as well as discovering something about their biology. Insects occur throughout the year, but are much more abundant during the warmer months in temperate regions. *Crawling insects* Specimens can be actively searched out; ground beetles beneath stones, or bugs and grasshoppers on vegetation. They can be collected in tins or jars. Entomologists use a pill box–a cylindrical box with a shallow lid and a clear glass or plastic bottom. When the box is inverted over the insect, it moves up towards the light, away from the open end which is then quickly covered by the lid. Smaller insects are collected by sucking them up into a pooter. (A corked suction bottle with two tubes inserted through the cork. One tube has its base covered with a piece of gauze and is connected to a piece of rubber tubing, which forms the mouthpiece for sucking small insects up through the other tube into the bottle.)

A variety of insects can be collected with a sweep net, by sweeping back and forth through the vegetation along roadside verges and the edges of woods. Insects caught in the net, can either be picked out by hand or sucked up in a pooter. From trees and tall shrubs insects can be collected by beating. A beating tray or even an inverted umbrella is held beneath the branches, which are sharply rapped with a stick dislodging bugs, caterpillars, flies or moths.

Flying insects These will have to be caught on the wing. A net for butterflies or any other flying insect should have a net bag that is light and soft and at least twice as long as the diameter of the net frame. As soon as it is inside the net, the insect is trapped by quickly flipping the bag over the frame.

Plate 23 Springtails *(Podura aquatica)* on water surface with pink water fern *(Azolla filiculoides)*. Aquarium with dual source oblique lighting from above water. × 2½ M

Plate 24 Parasitic larval water mites on underside of water scorpion *(Nepa cinerea)*. Aquarium with two flash. × 6

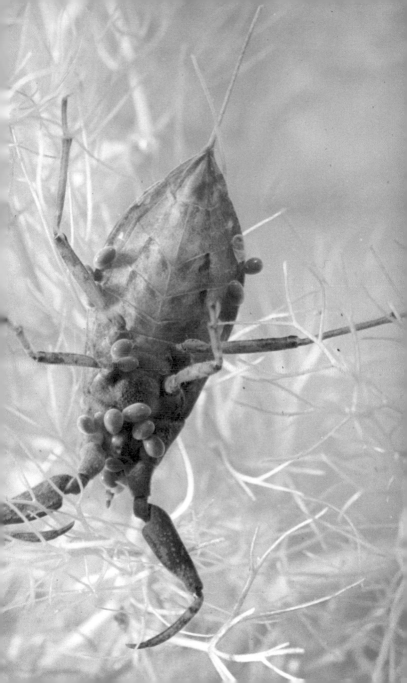

Keeping

Once captured, an insect must be contained until it can be photographed. An adequate temporary container is a jam jar covered over with a piece of nylon tights or with perforated paper. Alternatively, use shoe boxes or clear plastic lunch boxes. The latter have the advantage that the insect can be viewed without removing the lid. Whatever the container, some vegetation should be added – if not for food, to provide shelter, support and a humid environment.

A breeding cage is a more suitable long term container for caterpillars, moths, butterflies and stick insects. Cages, available from entomological suppliers, may be either a wooden box with gauze side panels and a removable glass front, or a clear plastic cylinder slid over a metal base and covered with a perforated lid.

Caterpillars are amongst the easiest of insects to keep in captivity. Apart from naturally gregarious species, it is better to keep only a few individuals in each container. Before collecting caterpillars make sure to note their food plant; some species which feed on a variety of plants may be reluctant to change their diet in captivity. If the food plant cannot be changed daily, it can be kept fresh longer by immersing the cut stems in a narrow necked jar of water in the breeding cage. Breeders feed up their caterpillars by confining them inside muslin sleeves on their food plant outdoors. Sleeving ensures a continuous fresh supply of food and also prevents birds from feeding on the caterpillars, and hymenopterous parasites attacking them.

Ants can be kept in an artificial nest or formicarium. This can be made from plaster of Paris, using an old shoe box as a mould. Interconnecting runways can be created by putting rolled strips of plasticine covered in vaseline in the bottom of the mould before the plaster is poured in.

In the studio

The basic requirement for an insect studio is a table or work bench – much of my photography has been done on the kitchen table.

Props Support the camera either on a tripod standing on the floor or a small table-top tripod on the work top. For horizontal shots, a waist level viewfinder or a right angle viewfinder attached to a fixed pentaprism, will save bending to focus the

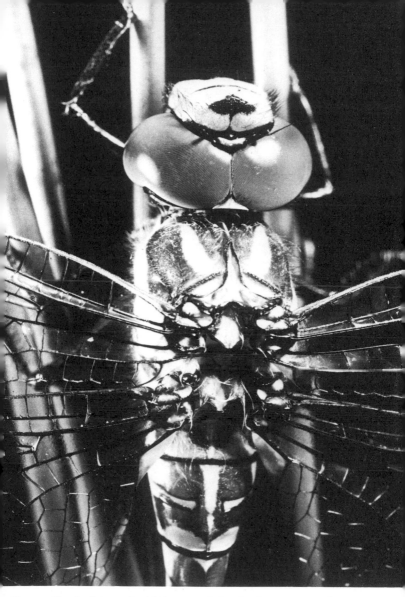

Fig. 5.2 Detail of dragonfly *(Aeshna cyanea)* showing large compound eyes. Studio with flash. × 5

camera. A copipod is a useful camera support for photographing crawling insects from overhead. For any macrophotography, critical focusing will be much easier if the camera is mounted on a focusing slide.

Plastic trays are useful for containing a layer of sand, soil or leaves for photographing insects from above. Lichen–covered logs or pieces of bark, make ideal backgrounds for cryptically coloured night-flying moths. Vegetation for insects to cling onto can be supported in plasticine, a jar of wet sand or any narrow necked container filled with water. Vegetation and backgrounds can be supported with clamp stands. Fill in any gaps in the natural props of bark, moss, soil or vegetation with a single-toned board. Pale blue artists' boards will simulate sky, but they will not create the same atmosphere as a genuine field picture. Black velvet is an effective and dramatic background for studio photography for both monochrome and colour – since it makes no attempt to be a natural background.

Lighting Photography in a conservatory using natural sunlight will most closely simulate *in situ* conditions, with the advantage of confining the subject. But most studio photography is done to supplement rather than to replace field photography. So indoor work will generally be left either to periods of bad weather or the evenings, when some form of artificial light will have to be used.

Photoflood lights are generally quite unsuitable for photographing insects, since they emit too much heat and are too bright for some insects. An ordinary 60 watt household bulb can be used to illuminate static subjects. If possible, before making a long exposure, lock up the mirror to eliminate any vibration. Flashlight is preferable for many subjects, and is essential for action pictures.

Try to select the direction of the light source(s) for each individual subject, rather than to use a standard set-up every time. A continuous light source, such as an Anglepoise lamp, or a narrow beamed spotlight, is ideal for viewing through a SLR camera the precise effect of light and shadow on the subject and the background, and for critical focusing. Colour photography using tungsten light sources will produce an overall false colour cast unless artificial light colour film is used. Alternatively, use daylight colour film with a colour conversion filter such as a Wratten 80B. Daylight colour film, however, can be used with electronic flash, which also has the advantage of producing light with a constant colour temperature. When using flashlight for

photography, substitute the flash for the focusing lights. Some professional flash units have their own built-in modelling lights.

The most obvious position for a single light source is in front of the subject on, or beside, the camera. However frontal lighting produces no modelling and is therefore rather 'flat'. It also casts unsightly shadows onto a pale background. By moving the light source round to one side of the subject (oblique lighting) better modelling will be gained. The shadowy unlit side of the subject can be filled-in by bouncing the light off a white board or a reflector. A variety of lighting positions can be used with two light sources such as dual source oblique lighting from in front or from behind. Back lighting is particularly effective for photographing hairy caterpillars or for insects with fine legs or antennae. Care must be taken though, to avoid light shining directly into the lens, which will result in flare.

For macro work in general, when the lens-to-subject distance is restricted, a ring flash is often recommended. While this type of frontal lighting can be useful for photographing hairy or scaly subjects, it is not recommended for all types of insects. If a ring flash is used to photograph insects with a flat shiny thorax or shiny wing cases it will produce a distracting circular reflection. Should this reflection happen to appear centrally, it can be misinterpreted as a body pattern—especially in a mono-chrome photograph. Masking parts of the ring flash may produce more acceptable lighting. Without a ring flash and if dual source oblique lighting in front of the subject proves impractical, experiment with lighting from other directions. Many of the photographs in this book have been taken by experimental lighting, and not one was taken with a ring flash.

An extension of back lighting is transmitted lighting, which shines directly through the subject, and can therefore be used for illustrating internal structures. The wings of many insects and the mines made by leaf miners (Fig. 5.3) are suitable subjects for transmitted lighting. To avoid flare, a diffuser, such as a sheet of opal glass or even a piece of greaseproof paper, should be placed between the light source and the subject. The lighting can either be flood or flash. A light box makes a convenient transmitted light source for flat subjects which can be laid on the top. Dark field illumination is a special kind of transmitted lighting, which shows the subject brightly lit against a black background. The subject is supported on a sheet of glass above the background and the lights are angled in beneath the subject, outside the field of view of the camera. Providing the lights are

correctly positioned, only light which is refracted by the subject will pass through the camera lens.

Beetles with shiny wing cases are never easy to photograph, since each direct light source will produce a highlight on the elytra. A single direct light source will simulate the reflection produced by sunlight and usually depicted by artists. However, a less obvious highlight produced by indirect lighting may be preferable. A continuous light source or a flash can be bounced off a white board or an umbrella specially designed for such lighting, placed above or to one side of the subject. The ladybird in Plate 15 was taken with a direct flash placed obliquely in front and another bounced flash directed in behind the beetle. An alternative method of indirect lighting is to arrange a cone of white board or thick white paper round the subject through which the light source is shone and diffused. The camera views the subject either from above through the apex of the cone, or through a gap in the side.

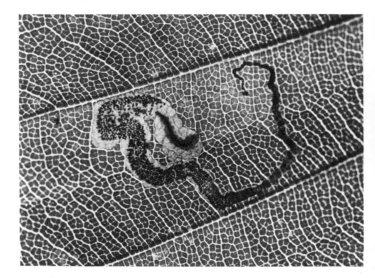

Fig. 5.3 Leaf miner in beech *(Fagus sylvatica)* leaf. Studio, transmitted flashlight.
$\times 7\frac{1}{2}$ M

Macrophotography These various types of lighting are also applicable to macrophotography. In addition, there are several other problems. Critical focusing is vital, so a SLR camera with a bright focusing screen will be a great advantage.

The definition is likely to be improved by reversing the lens. A reversing ring is attached to the free end of the tubes or bellows, so that the lens can be turned round. A short extension tube can be used as a lens hood. Reversal has the disadvantage of losing the automatic coupling with FAD lenses, but is not necessarily essential for achieving satisfactory pictures at magnifications of greater than $1:1$.

The exact scale of reproduction should always be recorded. Magnifications are given on some bellows for their use with a standard lens. These will, of course, change if a shorter or a longer focal length lens is used. Changing the focal length of the lens not only alters the magnification but also the perspective. The choice of what lens to use, will be a compromise between an acceptable perspective, the minimum amount of extension (for maintaining a rigid set-up) and the maximum camera-to-subject distance for adequately lighting the subject. For a given amount of extension, a wide angle lens will give a greater magnification than a standard lens, but with a reduction in the lens–to–subject distance. A long focus lens will produce a smaller magnification, and will increase the lens–to–subject distance.

Confining insects Active insects may have to be confined for critical photography indoors. Flying insects can be enclosed with some vegetation in a loose box–either an open–bottomed box made from a wire framework covered with transparent cellophane or a cylinder of clear plastic with a lid. Whenever the insect settles on the inside of the box, it is persuaded to move by tapping the outside, until eventually it settles on the plant. All doors should be closed and any open aquaria covered before the loose box is gently removed for the photography.

Crawling insects can be just as difficult to photograph. Primitive nocturnal insects which shun bright lights, will scuttle beneath any cover as soon as the focusing light is switched on. A barrier such as a water moat, a plastic ring and even a glass tank can be used to confine a crawling insect. Flattened crawling insects are best photographed from overhead (or from below crawling over glass). Mount the camera on a copipod or a reversed tripod head and prefocus on a small piece of crumpled foil. Mark the boundaries of the field of view and position the lighting before releasing the insect onto the substrate. Release

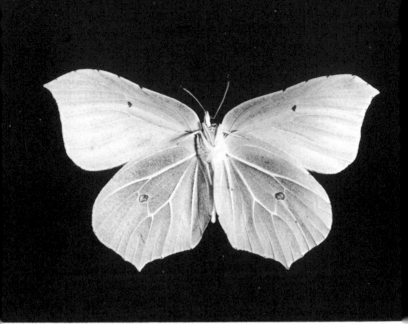

Fig. 5.4 Male brimstone butterfly *(Gonepteryx rhamni)*. Set specimen in studio. *Above:* in visible light. *Below:* in ultra-violet light.

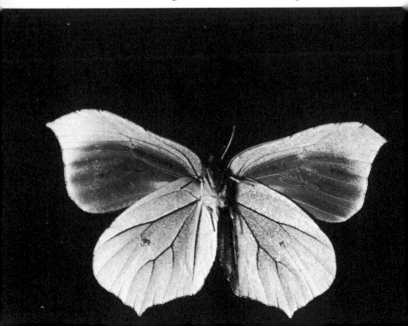

the shutter as the insect moves into the outlined field. A much greater proportion of successful pictures will be achieved by anticipating the insect's movements, rather than by watching for it to appear in the camera viewfinder. The base of a pill box can be used as a miniature loose box for confining crawling insects.

A brief period of chilling in a refrigerator will slow an active insect, but is not often to be recommended since the insect's pose immediately after chilling will appear moribund. The period between the insect warming up and either crawling or flying away is often very brief. As a last resort chilling can be used for butterflies and moths which would otherwise damage their wings by flying into objects. It is far better to study the behaviour of each particular insect and to photograph it during its quiescent phase; for instance, during the daytime for a night-flying moth.

Dead insects Photography of dead or mounted specimens is the only way of recording some rare species. Aberrations between individuals of a species, collected over a long period, can be illustrated in a single photograph. A dead insect should always be photographed against a single toned background. To infer it was alive by placing it amongst foliage will not fool any entomologist or competent naturalist. Pale moths and butterflies can be pinned directly onto a dark background, such as black velvet. Dark insects can be pinned onto tiny pieces of cork or plasticine on a sheet of glass raised up from a pale background. Shadows cast by oblique top lighting will then appear outside the field of view. Cut off a large pinhead and as much shank as possible above the insect so that it does not obscure part of the body or cast shadows across it. The brimstone shown in Fig. 5.4 was a set unpinned specimen, which was photographed in visible light using a household bulb, and then in ultra-violet light using a mercury vapour bulb.

Fig. 6.1 Water stick insect (*Ranatra lin*
feeding on midge larva.
Aquarium with two flash. ×4

Some insects spend their immature stages in freshwater and emerge as adults (dragonflies, stoneflies, mayflies, alder flies) while a few insects are completely aquatic throughout their life history (beetles, water scorpion, water stick insect).

In situ

Submerged aquatic insects are very difficult to photograph in the field. The water in ponds and canals is either too murky, or too dark for photography. Turbulent river waters are equally impractical. Therefore, either adult flying insects resting on the waterside vegetation, or insects which walk over the water surface, are most suitable for outside photography. Better pictures of other aquatic insects will be achieved by transferring them to an aquarium for photography.

Beside water A towpath running alongside a canal is an excellent place for finding adult dragonflies, mayflies, stoneflies and caddis flies on the emergent vegetation at the water's edge. As when stalking any insects in the field, move towards them slowly and carefully. Alder flies are sluggish fliers, so that even when disturbed, they soon come to rest again.

Larval and adult mayflies and caddis flies which are the food of trout and salmon, are mimicked by fly fishermen making their wet and dry flies. Fishermen have evolved their own delightful names for many of these flies, such as February red (stonefly), blue-winged olive, March brown and Greendrake (mayflies). Spectacular mayfly hatches occur occasionally when huge numbers of insects rise up from the surface of the water. These are not the adult mayflies, but the sub-imago stage– referred to by fishermen as the dun. Mayflies are unique in moulting after they have reached a stage which is capable of flying. But the sub-imago stage is brief and from it emerges the adult or spinner.

On water Insects which walk on water include pondskaters, whirligig beetles, and tiny primitive springtails (Plate 23). Whirligig beetles are the most difficult to photograph since they move so rapidly and can also escape by diving. Pondskaters will move away from any disturbance, but they will soon return– especially if they can feed on a drowned corpse.

Better quality pictures will be achieved by using the camera on a tripod if possible, rather than hand-holding it. Before

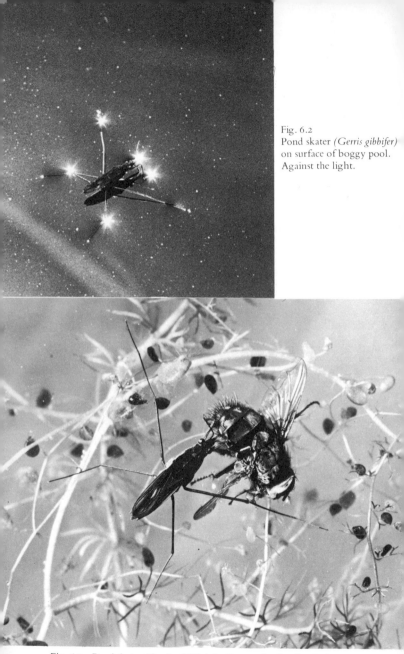

Fig. 6.2
Pond skater *(Gerris gibbifer)*
on surface of boggy pool.
Against the light.

Fig. 6.3 Pond skater *(Gerris gibbifer)* feeding on fly. Studio, dual source oblique
flash above water surface. × 3

attaching the camera, check the depth of water and the type of bottom. Push the tripod legs firmly into the bottom. This may stir up murky clouds, which can help to increase the contrast between the dark insect and the water. Freshwater is not nearly so corrosive as sea water, but none the less, tripod legs should be cleaned and dried after immersion in water.

A polarizing filter which can be such an asset for reducing the surface reflections when photographing *through* water, is not essential for taking insects on the surface–in fact reflections of white clouds can provide a background which contrasts better than water with no sky reflections. But always look critically for reflections of overhanging branches, which can distract attention from the subject itself. Photograph pond skaters against the light to emphasize the dimples made by their legs resting on the water surface (Fig. 6.2).

The raft spider in Fig. 6.4 is included as an example of a larger animal which walks on water. It was photographed on a boggy pool by lying prostrate on a wooden bridge and bracing the camera against the side of the bridge.

In aquaria

The only way to produce critical close-ups illustrating the way in which aquatic insects move, breathe and feed in their under-water environment is by collecting and photographing them in an aquarium. Such controlled photography is not easy and straightforward; there are many problems which have to be overcome before a perfect picture is achieved.

Collecting Most freshwater life can be collected with a water net, made from nylon or terylene netting and a robust frame which will not buckle when the net is thrust amongst weeds underwater. A grapnel is also useful for dragging up submerged pondweeds for various crawling insect life. A white pie dish or a developing dish is ideal for a preliminary sorting of the catch. Make sure to segregate the predators (bugs, water beetles and their larvae) before bringing them home, otherwise they will damage or kill other specimens. Freshwater life can be carried in any containers with water-tight lids in a bucket.

Insects collected from fast flowing streams or rivers must be kept cool and have their water aerated with a small aquarium pump as soon as possible after collection. Remember to cover all containers, since some adult aquatic insects, such as water beetles and backswimmers can crawl out and fly off.

Setting up the aquarium Aquaria can be bought or made in a variety of sizes, but a conventional small glass aquarium measuring 30 × 20 × 20 cm will be adequate for photographing many subjects. Perspex aquaria are cheaper than glass ones, but because they scratch so easily they are not suitable for photography through their sides. They can, however, be used for keeping livestock. Non-standard sized glass aquaria can be made by using the special glass adhesive sold in aquarium or pet shops. Since this adhesive is at first toxic, a newly made tank should not be used immediately and should be given several changes of water before it is first used.

Before the aquarium is set up for photography it should be cleaned and checked for leaks. At least one of the four walls should be flawless and preferably made of plate glass. If an aquarium is kept in a sunny position, a green algal growth will soon develop inside. This can be scraped off using a razor blade or a plastic scraper. Place the aquarium in position for photography before filling it with water. Use filtered pond or river

Fig. 6.4 Raft spider *(Dolomedes fimbriatus)* resting on surface of boggy pool. Against the light.

water, or rain water in preference to tap water. If tap water has to be used, allow it to stand overnight so it is no longer toxic (chlorine is used to sterilize tap water).

Water can be filtered using a kitchen sieve or filter paper. But even filtered water will not remain clear for long, since once animals are introduced they will soon defaecate. This is not such a problem with small insects as with large fish. The aquarium water can be continuously filtered by pumping water, using the aerator as an air-lift, through a filter placed in one corner.

The background in the aquarium can either be naturalistic weeds and stones, or an artificial single toned board. A plain background–especially black–can be useful for illustrating the structure of some insects. Objects such as weeds are essential for positively buoyant insects to cling onto underwater otherwise they will rise to the surface. Always collect weeds and bottom substrate from the same locality as the insect to provide authentic surroundings. Wash both weeds and stones before adding them to the aquarium. Anchor with stones any weeds which tend to float up to the surface.

The temperature of both the aquarium water and the studio should be similar to the outside water temperature. Condensation will develop on the outside of a cold water aquarium set up in a warm room. Most aquatic animals will tolerate a small, gradual temperature increase, but insects from cold, highly oxygenated waters will die very quickly in warm water.

Lighting Photoflood lighting is not suitable for photographing aquatic life, since it emits too much heat. Heat filters can be used, but they necessitate a larger working area. An ordinary light bulb can be used as a focusing light and for checking the best direction for lighting the subject. The photography of small active animals is best done with electronic flash. Lighting an aquarium from overhead, most closely simulates natural sunlight; however, the position of the light sources can be varied to suit the subject and the aquarium. If the aquarium has four clear walls, it can be lit through the sides, through the front or even through the back wall. Reflectors can be used in combination with one or more light sources.

The correct positioning of lights through both the front and back walls is critical when photographing through the front glass. Reflections of the light sources will appear in the front glass unless the lights are positioned well to one side of the camera, at an angle of about 45° to the glass. Back lighting should be angled in obliquely so as to avoid flare.

Fig. 6.5 Diving beetle *(Dytiscus marginalis)* swimming over bottom. Aquarium with single overhead flash. × 2½

Reflections of the camera or of the tripod or hands in the front glass so often ruin aquarium photographs. These reflections can be eliminated by attaching a matt black board, with a central hole cut out for the lens, to the front of the camera. For close-up work, a 20 cm square mask is adequate.

The correct exposure for aquarium photography with flash will have to be determined by taking a range of bracketed exposures and keeping careful notes. The many variables which affect the exposure include film speed, guide number of the flash, magnification, flash-to-subject distance, the size of the aquarium and the tone of both the subject and the background. As with all close-up photography, use small apertures to gain maximum depth of field.

Surface animals are best photographed with the camera mounted above the aquarium. The conventional shaped aquarium can then be replaced with any shallow container – even a plastic lunch box, since the photography is not done through the side. The camera can either be mounted on a copipod or on the reversed head of a tripod. Adjustable rack and pinion movements on the copipod or a focusing slide, will be a great asset for critical focusing.

To prevent reflections appearing in the field of view, the light sources must be correctly positioned above the water to one side of the camera at an angle of 45° or less to the water surface. Flattened subjects which creep over the bottom can be photographed from above and illuminated through the sides of the tank rather than down through the surface. For any overhead photography, dark backgrounds will avoid the shadow problem created by lighting a subject against a pale background.

Until all the basic problems associated with tank photography have been overcome, the first subjects to try photographing are portrait shots of less active insects. As more experience is gained, progress onto moving subjects and action shots of swimming and feeding.

BL Detail of outside of wasp's nest.
Available light.

BR Galleries made by elm bark beetle and l
(Scolytus sp.). Studio, photoflood. × 1

CHAPTER 7 INSECT PATTERNS

The most direct approach to photographing insects is to record their overall shape, colour and structure as well as their behaviour. A less obvious approach is to photograph the structure of their homes—some insects are superb architects—both as individuals and in colonies. Insects examined with a hand lens will reveal a whole range of possible macrophotographs.

Architecture The hexagonal waxy cells of honeybee comb are an example of a repetitive pattern. The outline of these cells can be shown most clearly in a photograph, after the cells have been extruded (Fig. 7.1TR) but before the workers fill them with honey or pollen, or the queen lays an egg inside them. Colonial wasps also construct layers of cells inside their nest (Fig. 3.1). The nest itself is built from wood scrapings which are masticated with saliva to form a papery substance. When different types of wood have been used, the outside of a completed nest has a whorled design (Fig. 7.1BL).

The tube-dwelling freshwater caddis larvae utilize a variety of objects for building their tubes. Sand, gravel, twigs and even shells are collected; leaves and rush stems are chewed into portions for sticking together into a distinctly shaped tube. Bagworms, which are terrestrial, construct their cases from leaves or twigs.

Dew-covered spiders' webs—especially those made by the orb spiders—are excellent subjects to photograph on misty autumn mornings. Go out early before the sun appears, to look for intact webs. Direct flashlight will not only provide added sparkle to the dew drops, but will isolate the web from a distant unlit background. Spraying dry webs with an atomiser can help to outline their structure, but it will not exactly simulate natural dew.

Anatomy The patterns and colours of butterfly and moth wings are built up from minute different coloured scales (modified hairs) which overlap like tiles on a roof. The name of the order to which these insects belong—the Lepidoptera—means scale wings. Iridescent colours are produced by microscopic sculpturing on the scales which interfere with the reflected light, so that these colours change as the angle of the light changes.

Photomicrography is most suitable for showing the shape of individual scales—including the special scent scales (androconia)

Fig. 7.2 Detail of portion of South American butterfly wing showing individual scales and eye spot marking. Studio with flash. × 12 M

found on some males; but macrophotographs can be taken of a group of scales (Fig. 7.2).

These scales normally cover and obscure the wing venation, which is so conspicuous in dragonflies and many flies. The pattern of this venation is often used as a means of identification. Enlargements of venation patterns in transparent wings can be made by placing a wing in the negative carrier of an enlarger and projecting the image onto a sheet of photographic printing paper. The direct negative image produced without using a camera, is known as a photogram (Fig. 7.3). By substituting the printing paper for a piece of sheet film, a negative can be made from which a positive contact print can then be obtained.

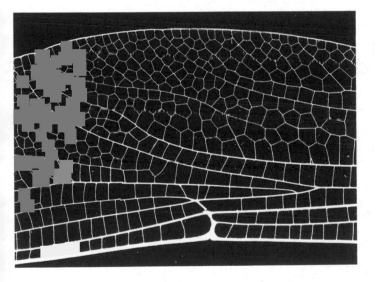

Fig. 7.3 Photogram of part of dragonfly wing. × 4

APPENDICES
A PHOTOGRAPHIC GLOSSARY

Aperture Iris diaphragm of lens which controls amount of light reaching film. Calibrated in 'numerical' apertures (f numbers or stops) which change by a factor of 1.4 ($\sqrt{2}$) in one stop increments in series 1, 1.4, 2, 2.8, 4, ... 16, 22 ...

Artificial light film Colour filmstock for use with photofloods or household light bulbs.

Ball and socket head Attached to tripod or other support to allow tilt and rotation of camera or flash.

Bellows Variable extension inserted between the lens and the camera body for close-up photography, allowing magnifications of greater than life size (1:1).

Bounced lighting Indirect diffuse lighting obtained by shining the light source(s) onto a white board, wall or umbrella, above or to one side of the subject.

Close-up lens (Supplementary lens) Fitted to front of camera lens for close-up photography.

Colour cast Unnatural colouring either due to using the incorrect film with a particular lighting (e.g. daylight film with photofloods) or to reflection from a coloured surface.

Conversion filter Used with colour films to correct overall colour balance for a film designed to be used at a different colour temperature, e.g. blue Wratten 80B used with daylight colour films and photoflood lighting; and orange Wratten 85 used with artificial light colour films in daylight.

Copipod Camera support with four legs used for overhead photography, especially copying work.

Dark field illumination Transmitted lighting, in which the subject appears brightly lit against a black background. Suitable for hairy and translucent subjects.

Depth of field Zone of sharp focus behind and in front of plane of focus. Increased by using a smaller aperture or by decreasing the image size. Particularly important in close-up work, when the depth of field becomes reduced.

Diaphragm See Fully automatic diaphragm and Preset diaphragm.

Diaphragm shutter Iris type shutter usually positioned between the lens elements, but sometimes behind or in front. Synchronized with electronic flash at all speeds.

Diffuse lighting Soft lighting which produces soft edged shadows, and least obvious highlights on shiny objects.

Electronic flash Reusable flash which produces an instantaneous discharge in a gas-filled tube.

Exposure Correct combination of shutter speed and lens aperture to produce a satisfactory negative or transparency for a given film speed and a particular light intensity.

Extension tubes Inserted between the camera body and the lens for close-up photography. Automatic tubes allow retention of fully automatic diaphragm mechanism.

Film speed Relative sensitivity of a film to light, expressed either as an ASA or a DIN rating. 'Slow' films have a low rating and require more light than 'fast' films.

Filter Alters the nature of light passing through the lens to the film, by absorbing particular wavelengths.

Flare Bright spots or patches formed by strong light reflections inside the lens, when the camera is pointed towards a light source. Flare can be reduced by using a lens hood or a multi-coated lens.

Focal length Distance from the film plane to the centre of the lens, when it is focused on infinity. Usually given in mm (or cm).

Focal plane shutter Camera shutter positioned immediately in front of the film plane, made of fabric or metal blinds.

Focus Adjusting the lens-film distance so that the subject image appears sharp on the film plane.

Focusing slide Used mounted on a tripod, it allows the camera to be moved towards or away from the subject for critical focusing in close-up work, without altering the magnification.

Frame A single exposure amongst a series on a film.

Fully automatic diaphragm (FAD) Allows lens to remain at full aperture until shutter release is operated, when the diaphragm closes down to the pre-selected aperture.

Grazed lighting (Textured lighting) Extreme low angled oblique lighting used for emphasizing texture.

Lens hood Projects in front of lens. It reduces the possibility of back lighting striking the front surface of the lens and thereby causing flare.

Long focus lens Has a focal length greater than the standard lens, and increases the camera-to-subject distance for a given image size. Covers an angle of view of less than $45°$.

Macro lens A lens with built-in extension allowing magnifications of up to 0·5 without using extension tubes or bellows.

Monopod A single legged camera support.

Non-reflex camera Includes field and viewfinder cameras which do not view the subject directly through the lens.

Over-exposure Due to excessive light reaching the film, colour transparencies appear thin and negatives dense.

Pentaprism Five sided prism used in SLR cameras to ensure the image is correctly orientated in the viewfinder.

Photoflood Artificial light used for studio work for monochrome and artificial light colour films.

Polarizing filter Used to reduce distracting reflections from water and glass or wet and shiny surfaces. It also darkens a blue sky.

Prefocus Setting focus of the lens either before moving camera in towards the subject or for a fixed camera-to-subject distance.

Preset diaphragm (PD) A non-automatic diaphragm in which the iris must be stopped down manually to the present aperture.

Reflex camera Has ground glass screen for critical composition and focusing. Twin lens reflex (TLR) cameras have two lenses, one for viewing and one for taking, while single lens reflex (SLR) cameras have one lens only.

Reversing ring Accessory for mounting the lens on the camera body in the reverse position for macrophotography.

Ring flash Electronic flash which encircles the camera lens. Provides frontal lighting for extreme close-ups.

SLR *See* Reflex camera.

Standard lens Has a focal length approximately equal to the diagonal of the negative or transparency, giving an angle of view of 45–$50°$.

Stop (f number) Numerical aperture of lens iris diaphragm which controls the intensity of light reaching the film.

Synchro-sunlight Balanced combination of sunlight and flashlight.

TLR *See* Reflex camera.

TTL (Through the lens) meter Reflected light meter built into a SLR camera which measures the light passing through the lens.

Transmitted light Light which passes through the subject.

Under-exposure Due to insufficient light reaching the film, colour transparencies appear dense and negatives thin.

Ultra-violet light Short wave lengths outside the visible spectrum.

Wide angle lens Short focal length lens giving a wider angle of view (greater than $50°$) than a standard lens used from the same position.

B EQUIPMENT CHECK-LIST FOR INSECT PHOTOGRAPHY

Basic field equipment

Camera with standard lens $\begin{cases} \text{(50mm for 35mm format)} \\ \text{(80mm for 6} \times \text{6cm format)} \end{cases}$ with lens hood

- Light meter (if camera does not have TTL metering)
- Films
- Tripod
- Monopod
- Spare batteries for TTL meter
- Cable release
- Close-up lenses and/or extension tubes
- Lens tissues and lens brush
- Gadget bag or foam-padded rucksack
- Reflector
- Right angled flash bracket
- Notebook or pocket tape recorder

Additional equipment

- Macro lens

Medium long focus lens $\begin{cases} \text{(105 or 135mm for 35mm format)} \\ \text{(150 or 250mm for 6} \times \text{6cm format)} \end{cases}$ with lens hood

- Flash (bulb or electronic)
- Z ring and double cable release
- Waist level or right angle viewfinder
- Umbrella or board for bounced lighting
- Copipod
- Pill boxes
- Pooter
- Net
- Beating tray

Additional studio equipment

- Breeding cage
- Plastic trays
- Loose box
- Aquarium
- Clamp stands
- Black velvet
- Board backgrounds
- Sheets of glass
- Spotlights
- White card
- Focusing slide
- Umbrella for bounced lighting
- Ring flash
- Reversing ring

C THE NATURE PHOTOGRAPHERS' CODE OF PRACTICE

All photographers working in Britain should read the following leaflets:

1) *The Nature Photographers' Code of Practice*, produced by the Association of Natural History Photographic Societies. Copies can be obtained from the RSPB, The Lodge, Sandy, Bedfordshire, SG19 2DL, by sending a stamped addressed envelope.

2) *A Code for Insect Collecting*
 Copies of which are obtainable free of charge from:
 Joint Committee for the Conservation of British Insects,
 c/o The Royal Entomological Society, 41 Queens Gate, London SW7.

D BOOKS FOR FURTHER READING AND IDENTIFICATION

★ Extensively illustrated with photographs.
† For identification of insects.

★ Angel, Heather, *Nature Photography: Its art and techniques*, Fountain Press/ M.A.P., Kings Langley, 1972.

† Beirne, B. P., *British pyralid and plume moths*, Warne, London, 1952.

† Burton, J., *The Oxford Book of Insects*, O.U.P., London, 1968.

 Butler, C. G., *The world of the honeybee*, Collins, London, 1954.

† Chinery, M., *A field guide to the Insects of Britain and Northern Europe*, Collins, London, 1973.

† Colyer, C. N., and Hammond, C. O., *Flies of the British Isles*, 2nd. edn., Warne, London, 1968

★ Cott, H. B., *Adaptive coloration in animals*, Methuen, London, 1940.

★† Darlington, A., *The pocket encyclopaedia of plant galls in colour*, Blandford Press, London, 1968.

 Ford, E. B., *Butterflies*, 3rd. edn., Collins, London, 1957.

 Ford, E. B., *Moths*, 3rd. edn., Collins, London, 1972.

 Ford, R. L. E., *Studying insects*, Warne, London, 1973.

 Free, J. B., and Butler, C. G., *Bumblebees*, Collins, London, 1959.

 Harris, J. R., *An angler's entomology*, 2nd. edn., Collins, London, 1959.

† Higgins, L. G. and Riley, N. D., *A field guide to the Butterflies of Britain and Europe*, Collins, London, 1970.

† Howarth, T. G., *South's British Butterflies*, Warne, London, 1973.

 Imms, A. D., *Insect natural history*, 3rd. edn., Collins, London, 1971.

 Imms, A. D., *A general textbook of entomology*, 9th edn., Methuen, London, 1957.

★ Klots, A. B., and Klots, E. B., *Living insects of the world*, Hamish Hamilton, London, 1959.

★ Linsenmaier, Walter, *Insects of the World*, McGraw Hill, (U.K.), 1972.

† Linssen, E. F., *Beetles of the British Isles*, Warne, London, 1959 (2 vols.).

† Longfield, C., *The dragonflies of the British Isles*, 2nd edn., Warne, London, 1949.

† Mellanby, H., *Animal Life in Fresh Water*, 6th edn., Methuen, London, 1963.

†★ Newman, L. Hugh, *Hawk-Moths of Great Britain and Europe*, Cassell, London, 1956.

 Oldroyd, H., *Collecting, preserving and studying insects*, 2nd. edn., Hutchinson, London, 1970.

★ Proctor, M. and Yeo, P., *The Pollination of flowers*, Collins, London, 1973.

† Ragge, D. R., *Grasshoppers, crickets and cockroaches of the British Isles*, Warne, London, 1965.

★ Sharell, R., *New Zealand insects and their story*, Collins, London, 1973.

† South, R., *The moths of the British Isles*, rev. H. M. Edelsten, Warne, London, 1961 (2 vols.).

† Southwood, T. R. E., and Leston, D., *Land and water bugs of the British Isles*, Warne, London, 1959

† Stokoe, W. J., and Stovin, G. H. T., *The caterpillars of the British butterflies*, Warne, London, 1944.

† Stokoe, W. J., and Stovin, G. H. T., *The caterpillars of the British moths*, Warne, London, 1959 (2 vols.).

† Step, E., *Bees, wasps, ants and allied insects of the British Isles*, Warne, London, 1946.

INDEX

Printed in England by W. S. Cowell Ltd, Ipswich